You can paint
Acrylics

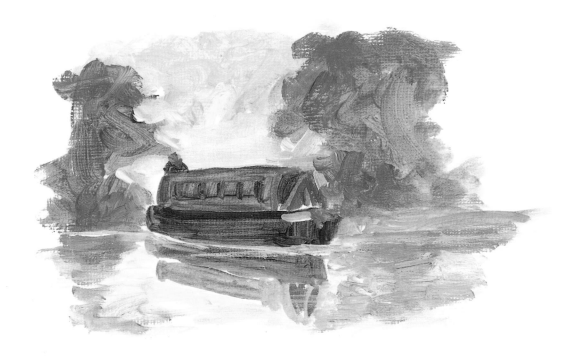

Melanie Cambridge writes for *Artist & Illustrator* magazine, and is the author of *Success with Oils* and *Learn to Paint landscapes in Oils* also published by Collins. Keen to encourage art at all levels, she runs various painting workshops and holidays, details of which can be found on her website www.melaniecambridge.com. A selection of Melanie's own work can be viewed at the Chase Art Centre, Wadebridge in Cornwall.

You can paint
Acrylics

Step-by-step acrylics
for the absolute beginner

MELANIE CAMBRIDGE

Collins

First published in 2003, this paperback edition
published in 2006 by Collins, an imprint of
HarperCollins Publishers
77-85 Fulham Palace Road
Hammersmith
London W6 8JB

Collins is a registered trademark of
HarperCollins Publishers Limited

The Collins website address is
www.collins.co.uk

09 08 07 06
8 7 6 5 4 3 2

A catalogue record of this book is available from the British Library

Editor: Isobel Smales
Designer: Penny Dawes
Photographer: Laura Knox
Title artwork: Sylvia Kwan

ISBN-13 978 0 00 723181 2
ISBN-10 0 00 723181 4

Colour reproduction by Colourscan, Singapore
Printed and bound by Printing Express, Hong Kong

CONTENTS

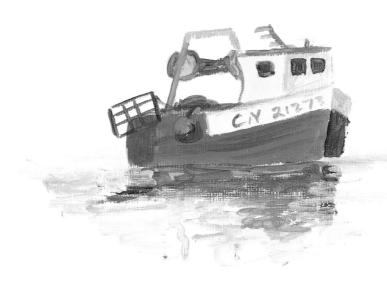

INTRODUCTION

I have often heard people say 'I wish I could paint' or 'I would love to paint but I'm no good at drawing'. If this is how you feel, then this is the book for you. With the right tuition and plenty of practice, anyone can learn to paint. Indeed, by picking up this book, you have already taken your very first step towards becoming an artist.

As adults, we often place very high expectations on ourselves, particularly when starting to paint. We assume that we should be able to paint well without any proper tuition or practice, and yet few people would expect to pick up a musical instrument and play it perfectly straight away. You need to learn the basics first.

Autumn Lane
18 x 13 cm
(7 x 5 in)

6

Quiet Reflections, Poole Harbour
13 x 18 cm (5 x 7 in)

Acrylics are a medium ideally suited to the beginner. You don't need lots of specialist equipment, just a few colours, brushes, paper and water. Because acrylics are an opaque paint it is easy to cover your mistakes (even light over dark colours) without having to start all over again.

This book has been written for the absolute beginner, so even if you have never picked up a brush before, it will show you where to start and then help you to progress. I have kept the instructions throughout the book very simple, and included enough basic techniques to get you started. It is important to practise these basic techniques first of all. Don't be tempted to skip a section, as each lesson builds on the previous one, helping you to acquire the skills you need to develop as an artist. Remember, learning should be fun, so take plenty of time to work through each section and expect to make lots of mistakes along the way. This is the only way you will learn.

Wherever I go to teach painting, I find beginners who struggle to draw the outline of a subject before they start to paint it. In this book I show you how to paint a variety of subjects by first looking at the basic shapes which make up each one, such as a house, tree or figure. Over the years I have found this approach to painting using block shapes rather than outlines is much easier for beginners as it takes away the pressure of producing a perfect drawing first of all. Hopefully you will find this different approach to painting as enlightening as I did when I first discovered it!

HOW TO USE THIS BOOK

The aim of this book is to get you started. You do not need to have any previous experience of painting or drawing; this book will help you to progress with confidence into acrylic painting.

Before you start painting, make time to read through the whole book. See how each section builds on lessons learnt in the previous ones. Try to become familiar with the names of the colours used so that you can recognize them quickly and easily once you begin painting. Now you are ready to begin. The early part of the book explains the different acrylic techniques. These pages will teach you

Springtime, Southern France
15 x 20 cm (6 x 8 in)

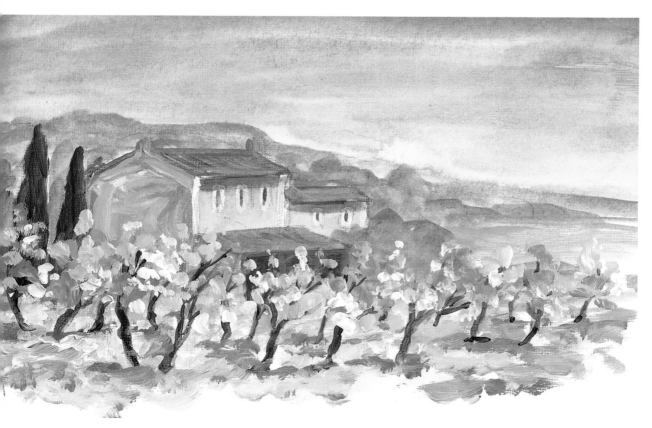

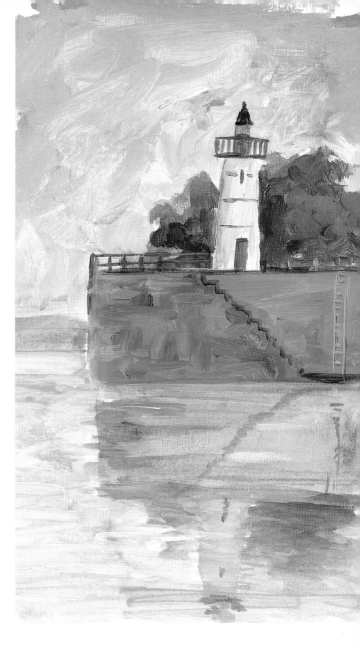

the very basics of applying paint to paper, and it is important that you acquire this basic knowledge before you attempt the lessons further on. Start by laying out all your materials in front of you. Simply gathering together the colours, brushes, paper and water jar somehow makes you feel as though you are already on your way to becoming a successful artist. Next, pick up one of the brushes and just enjoy making a few marks. Then add some water to see how the paint changes. This messing around with your materials will help you to become more familiar with them. The more comfortable you feel with your materials, the easier it will be to use them.

Because most people learn first of all by copying, you will find easy to follow step-by-step exercises and demonstrations throughout this book. These lessons are there to help you to understand the basic techniques first of all before moving on to show you how to produce simple paintings starting with fruit and flowers. More complicated subjects such as figures and animals are covered towards the end of the book. As you progress towards the latter stages of the book, not only will you have learnt the basic techniques of acrylic painting, but you should be starting to develop your own 'artist's eye' and finding potential subjects all around you.

Make the time to work through each exercise properly and practise on your own as

The Old Lighthouse, Honfleur
18 x 13 cm (7 x 5 in)

well. Learning should be fun, so relax and enjoy each stage rather than rushing to reach the next one. Taking time to understand each stage will help you to improve your paintings and, as your skills develop, so your confidence will increase until you are producing paintings you can be really proud of. Good luck!

BASIC MATERIALS

As a beginner it can be very tempting to go down to your local art shop and buy a whole range of expensive materials and colours. However, the more materials you have, the more there are to master. A basic palette of eight colours, several brushes and some acrylic paper will be fine to begin with.

Painting surfaces Acrylic paints can be used on any non-shiny, non-oily surface. Acrylic coated paper is probably one of the best and cheapest options but heavyweight watercolour paper, canvas, canvas boards and even hardboard can be used, but prime the smooth side with at least two coats of acrylic primer first. Unfortunately, once dry, acrylics also cling particularly well to clothing, carpets and furnishings, so take care to wipe up any marks whilst they are still wet!

Paints Acrylic paints usually come in two quality grades, student quality such as Daler-Rowney's System 3, ideal for beginners, or artist quality ranges such as Cryla. The paints come in tubes of 75 ml or pots of 250 ml or larger. The tubes will be fine to begin with, but buy a 250 ml pot of white paint. To mix paler colours you will add white rather than just thinning them with water, and therefore you tend to use more white than any other colour. My recommended basic palette is: Ultramarine, Coeruleum, Cadmium Orange, Crimson, Sap Green, Lemon Yellow, Raw Sienna, Burnt Sienna and Titanium White.

Brushes There are several ranges of brushes designed specifically for acrylic paints. These are nylon and have more spring than a watercolour brush. I recommend that you start with two acrylic brushes and one watercolour brush. Buy a No.12 round watercolour wash brush, a 12 mm short flat acrylic brush and a

A selection of painting surfaces together with Texture Paste and mediums used in this book.

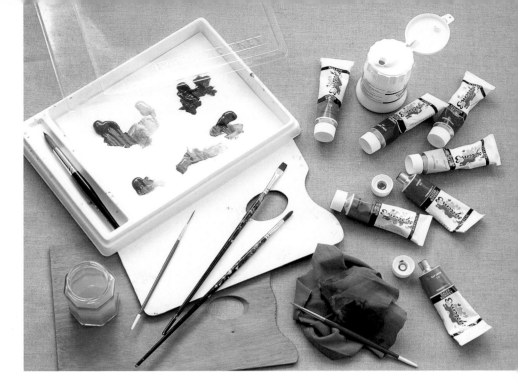

Acrylic colours laid out on a stay-wet palette ready for use, together with brushes and separate mixing palettes.

No.4 round acrylic detail brush. The higher the number, the larger the brush.

Mediums and Texture Paste There are various additives available for acrylic paints. These can be blended with your individual colours before being used in a painting. I recommend the following, which I have used in the book. Pearlescent Medium usually comes in a tube and has the same consistency as acrylic paint. It is most effective when mixed with a little acrylic colour to create a metallic version of that colour. Gloss Medium is a thin, milky substance that can be used to create a transluscent glaze. Texture Paste is used to increase the bulk of acrylic paint, enabling you to produce a very textured finish.

The stay-wet palette Acrylic paints can dry very quickly if they are simply squeezed onto an empty palette, so to prevent this I suggest you use two different palettes: a stay-wet palette on which to lay out your colours, and a separate plastic or melamine palette on which

to mix your colours. The stay-wet palette is essentially a shallow tray with a lid. Place several sheets of absorbent paper such as kitchen towel in the bottom of the tray, then dampen this surface with a water sprayer. Next place a single sheet of baking parchment over the top and lay out your colours on this. By keeping the tray damp with the occasional spray of water and sealing with the lid when not in use, the paint should stay useable for several days. The paper surface is not ideal for mixing on as it tears easily, so use your second palette for mixing. The paint will dry out as you work, but the palette can be cleaned at the end of each painting session by running under a tap and rubbing gently with a metal pan scrubber.

Other items The following items will also come in useful: a water jar and small water sprayer, palette knife for mixing colours and working with Texture Paste, plenty of rags for wiping brushes and cleaning up, a soft 2B pencil, sketchbook and eraser.

BASIC TECHNIQUES

A painting technique is simply a way of applying paint to paper. Over the next few pages, I show you the basic techniques for painting with acrylics. Try each of them in turn and practise as often as you can. This will give you the basic skills you need to become a successful acrylic painter.

Brushmarks

When you first start to paint with acrylics, the most important thing to recognize is the power of the brush stroke itself. Having the confidence to make textured marks, where the brush stroke is clearly visible, is one of the key elements in acrylic painting.

Load the flat brush with pure colour (don't dip the brush in water first) and simply enjoy making marks on the paper. Use the edge of the brush as well as the flat side and vary the pressure on the paper. Now try the same using the No.4 round brush.

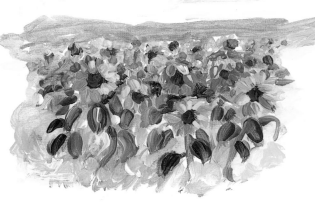

In this study of sunflowers, I used thick paint, applied in separate brush strokes to make the petals of each flower. See how they stand out from the paper.

Dry brush

Dry brush is a technique where the brush skips over the paper leaving paint in some places and missing others. It is fun to do but does need a little practice to get it right. It is very useful for painting sunlit water or creating textured furrows.

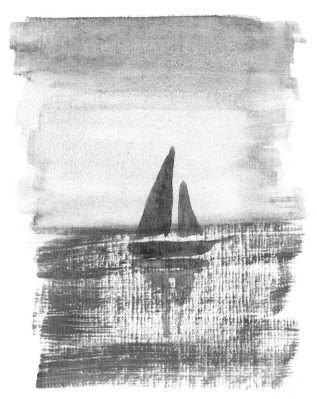

Load the flat brush with paint. Then wipe off excess colour by stroking the brush over some kitchen paper. Using fairly light pressure, drag the brush over the paper to create broken lines of colour.

Here I have used horizontal dry brush strokes to create the effect of shimmering light on water.

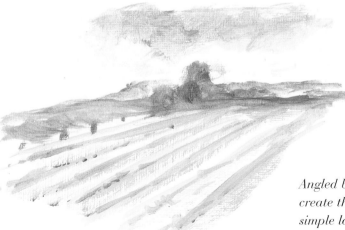

Angled brush strokes were used to create the ploughed field in this simple landscape.

Adding water

Acrylics are wonderful to paint with when used in their normal thick, buttery consistency, but they can also be thinned down with water to a wash-like consistency more akin to watercolours. Whenever you use these 'watery' techniques, use the watercolour brush, as its softer bristles will help you to achieve a soft, thin layer of colour.

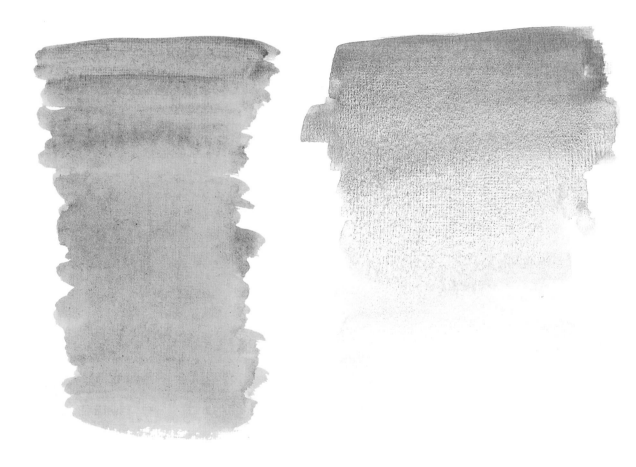

Flat wash. Tilt the paper to around 45 degrees before you start painting. Begin at the top of the paper with the watercolour brush loaded with plenty of watery paint. Work in horizontal lines of colour across the page. Let each line of colour just cover the previous one and add enough water to keep the paint blending together as you work down the page.

Graded wash. Start painting this wash in the same way as for the flat wash, but this time increase the amount of water in your paint as you work down the page. The colour gradually gets paler and you will end up with almost pure water at the very bottom. The graded wash technique is very useful for painting skies.

Adding other colours

Having practised painting washes with just one colour, now let's move on to working with several colours at once. These techniques are particularly exciting, even if the results are sometimes unexpected, as colour can tend to run out of control at times. Don't worry about these 'happy accidents', they are all part of the painting process.

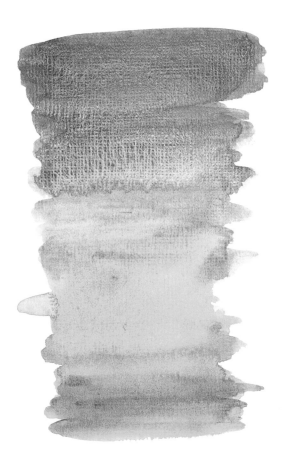

Graded colour wash. Washes don't need to be just one colour. Here I started with Ultramarine and gradually changed the colour to Raw Sienna and then Crimson. Keep the strength of each colour the same as you work down the paper, and clean your brush each time you change colour. This technique requires a little practice to get it right but it is worth the effort.

Wet-on-wet. The last of the 'watery' techniques is to apply the paint wet-on-wet. Paint a wash of Lemon Yellow. Whilst this is still wet, add blobs of Crimson and Ultramarine. See how the paint disperses and blends with the wet yellow. Depending on how much water you use and how wet the underlying wash is, the results can vary considerably, so take time to experiment.

Scumbling

Scumbling is when fairly dry paint is lightly brushed over an existing layer of dry colour to create a broken pattern where both colours are visible. This scumbled layer of two colours is very useful as a background. or to give the impression of soft wispy clouds such as those in a mackerel sky.

Paint a wash of Raw Sienna over the paper. Once dry, lightly brush over the same area with Burnt Sienna, this time using the paint without adding any water. Use fairly light pressure on the brush and allow patches of the first colour to show through.

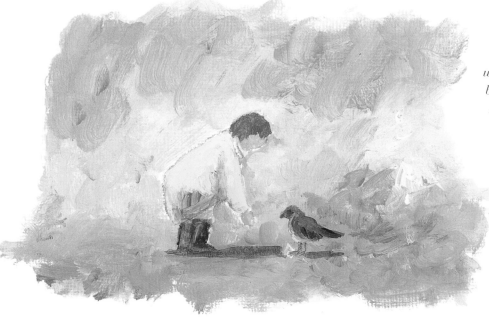

In this study of a toddler and pigeon, white is scumbled over both Ultramarine and Raw Sienna to create the soft background.

Glazing

Glazes are very thin layers of translucent colour which are painted over dry areas of colour to tint them. Glazes are a simple way to paint shadows. You will need to mix the paint with Gloss Medium instead of water to create a glaze.

Mix a little Ultramarine into Gloss Medium to create a sticky, pale blue glaze. Use only a little paint with at least three times the amount of medium.

Glazing has been used to paint the shadows on this white vase. First paint the vase shape with the No.4 round brush using solid colour, and allow this to dry. Add a background of Ultramarine to make the vase stand out. Now, using Gloss Medium with a little Ultramarine for a pale blue glaze, paint in the shadow areas on the right-hand side and under the rim.

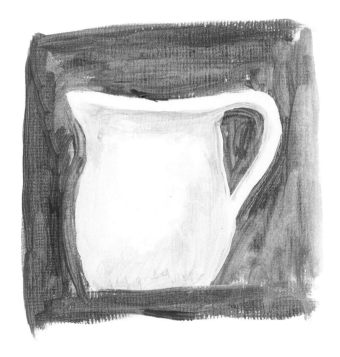

Impasto

Impasto is a technique where paint is applied extremely thickly to give a textured surface. By adding Texture Paste to acrylic colours, the consistency of the paint can be changed to make your colours extremely thick and heavy. Don't add more than about 30 per cent paste to your colours, or they may become rather chalky.

Mix some Texture Paste into Crimson and then brush onto the paper with the flat brush. You may prefer to use a palette knife as the paint mixture should be extremely thick. Both brush and knife create a very textured finish.

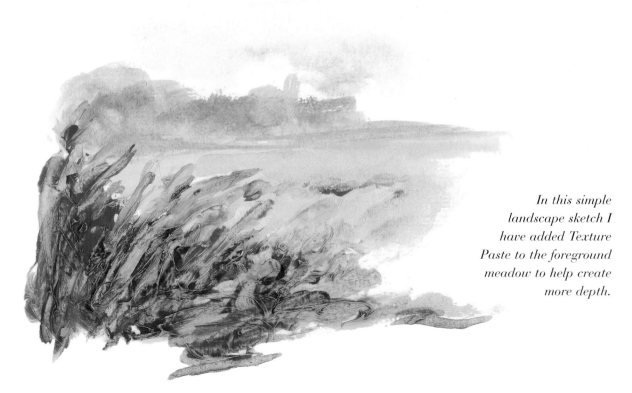

In this simple landscape sketch I have added Texture Paste to the foreground meadow to help create more depth.

Special effects

Another unusual effect you can achieve with acrylics is a metallic finish. Pearlescent Medium is about the same consistency as white paint but contains metallic flakes. It can be used on its own as a pearlised finish, or mixed with acrylic colours to create metallic colours. It is particularly useful for mixing silver and gold shades as shown here.

Add a little Raw Sienna to Pearlescent Medium for a soft gold tone. To make silver, mix the medium with a small amount of Coeruleum.

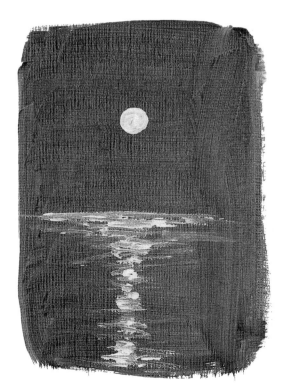

Metallic colours can be fun to use, even in a landscape. For this moonlit scene, start by painting a flat area of Ultramarine with the flat brush. Then paint in the silver moon and reflections on the water using Pearlescent Medium and Coeruleum.

EASY COLOUR MIXING

In theory it should be possible to mix all the colours you need from the three primaries – red, yellow and blue – but in practice this is difficult to achieve. The paintings in this book have all been produced using the eight colours which make up my basic palette. Practise mixing these colours together whenever you can. Mixing colours is a key skill you will need to become a really good artist.

Starter palette

The basic palette consists of two shades of blue, two shades of yellow, two shades of orange, one red and one green, plus Titanium White for mixing paler shades.

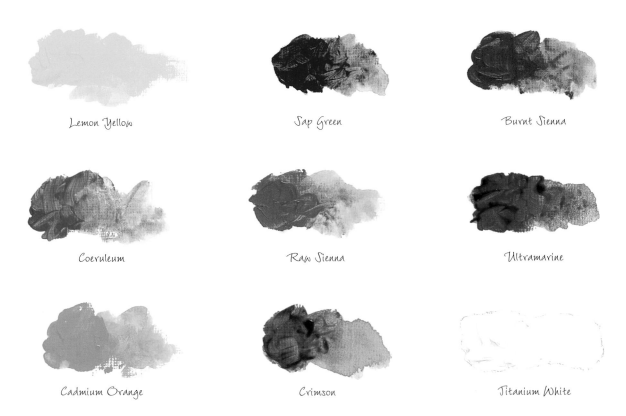

Lemon Yellow	Sap Green	Burnt Sienna
Coeruleum	Raw Sienna	Ultramarine
Cadmium Orange	Crimson	Titanium White

Predominant colour first

Whenever you mix a colour on your palette, always start off with the predominant colour. So if you are mixing a yellowish-green, start with yellow and slowly add a little blue until you reach the green you want. If you start off with blue, you will find it takes a lot of yellow paint to get the same result. Not only can this be frustrating, but you will tend to waste rather a lot of paint in the process. So remember, predominant colour first.

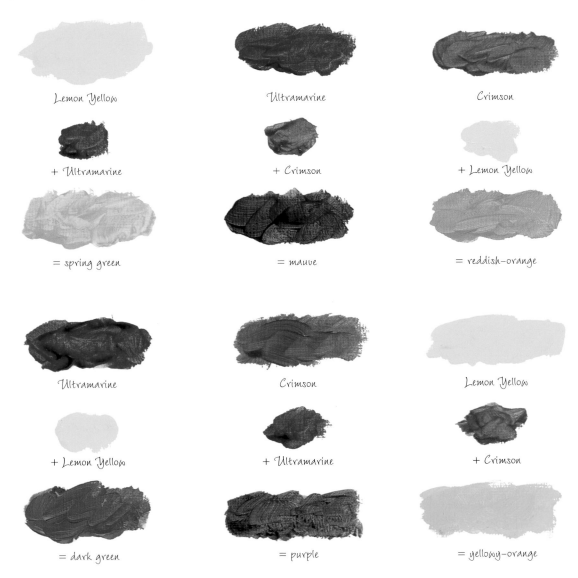

Lemon Yellow	Ultramarine	Crimson
+ Ultramarine	+ Crimson	+ Lemon Yellow
= spring green	= mauve	= reddish-orange
Ultramarine	Crimson	Lemon Yellow
+ Lemon Yellow	+ Ultramarine	+ Crimson
= dark green	= purple	= yellowy-orange

See how in each of these colour mixes, I have put the predominant colour first. The amount of paint you will need is also important. Not only should you start with the predominant colour on your palette, but you will probably need more of this colour than of the secondary one.

Working with white

Because acrylic paints are opaque, you will need to add white paint to mix paler shades, rather than simply adding water to lighten the colour. Once you add white paint to your mix, the paint changes from pure colours to what is known as 'body colour'. The white paint gives the colour 'body', making it appear more solid and opaque.

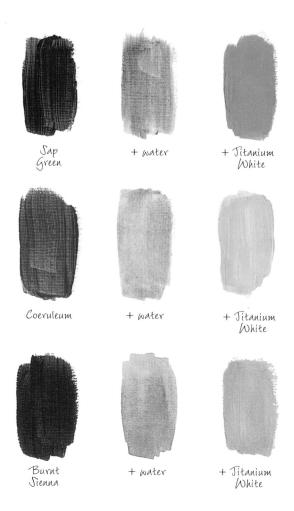

Sap Green + water + Titanium White

Coeruleum + water + Titanium White

Burnt Sienna + water + Titanium White

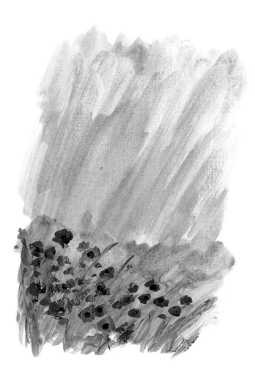

These poppies were painted with pure colour and so stand out against the background where body colour predominates.

Here you can see how the colours are changed by adding white. Those in the middle have been lightened simply by adding more water, whilst on the right I have used white paint to mix the paler shades. This use of white to make the paint paler is one of the fundamental differences between acrylics and watercolours.

Mixing grey tones

Mixing grey tones is a very important lesson to master, particularly when you start painting skies. These subtle colours will help you to paint wonderful clouds, and bluer greys will help to create distance in landscape subjects. Copy this exercise carefully and then practise until you are confident that you can mix the grey shade you need first time round.

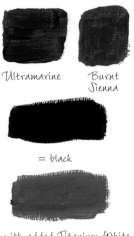

Coeruleum + Cadmium Orange

Cadmium Orange + Coeruleum

= cool grey

= warm grey

with added Titanium White

Coeruleum and Cadmium Orange tend to produce the best grey shades. See how much cooler the blue-grey shade is when Coeruleum was the predominant colour. The warmer orange-grey is almost beige.

Ultramarine Burnt Sienna

= black

with added Titanium White = medium grey tone

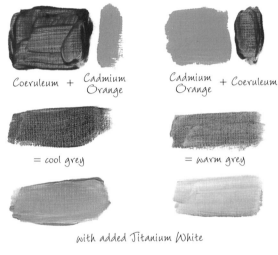

In this sky study, see how many different grey shades you can find. There are quite a few!

I do not recommend you have black on your palette because it can be tempting simply to add black to other colours to create darker shades. However, there may be times when you need a black or very dark shade. Mix Burnt Sienna and Ultramarine for black, but add a little more blue than Burnt Sienna, or you may end up with a dark brown.

MAKING OBJECTS LOOK 3-D

As painting is in only two dimensions, to make objects appear solid you need to create the illusion of depth by painting the shadows and highlights. This is probably the most important lesson to master on your journey towards becoming an artist. It is only by painting light against dark that you can show shape and form. If your painting looks flat, check your shadows.

Adding shadows

When adding shadows, remember to wait until the underlying paint is dry before you start. Then use a thin wash of Ultramarine and Crimson (with plenty of water) to paint in the shadow areas.

See how this box is merely a flat shape until the contrasting shadow is added. The shadow alongside the box helps to anchor it to the ground.

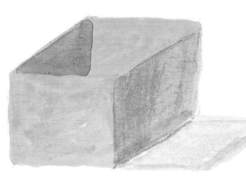

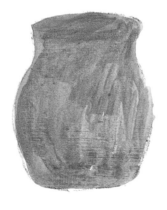
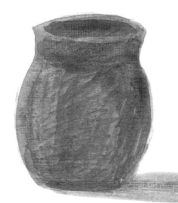

Painting a shadow inside the rim of this vase makes it appear hollow.

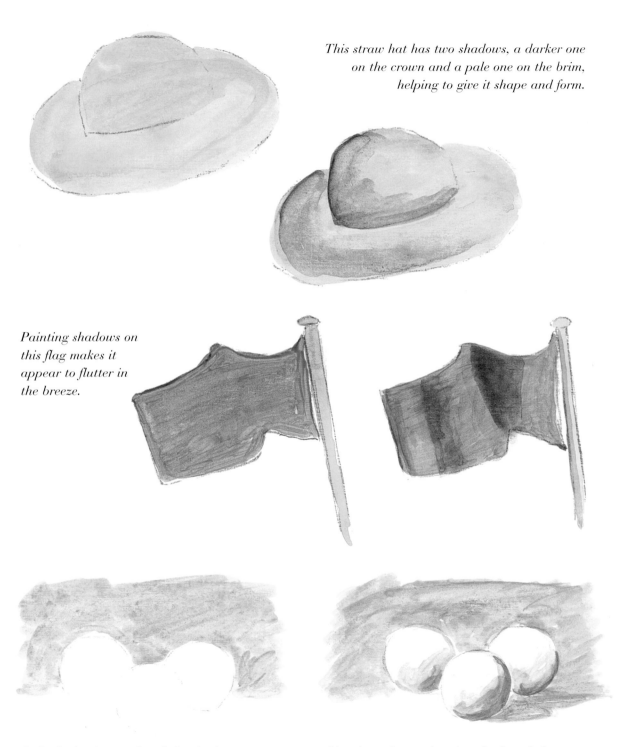

This straw hat has two shadows, a darker one on the crown and a pale one on the brim, helping to give it shape and form.

Painting shadows on this flag makes it appear to flutter in the breeze.

Only the background and the shadows on these white balls were actually painted.

Note how the overlapping shadows help to add a sense of depth to the painting.

You can paint 25

FRUIT

Fruit is a familiar subject to most people and is a good subject for beginners. The shapes of more common types are fairly simple, so you can practise your newly learned techniques and colour mixes without having to master any complicated drawing before you start.

Apricots

For these apricots, I used the brushmarks themselves to add texture, painting the shadows wet-on-wet so that they blended and became part of the fruit's surface. Notice how the shadow beneath the fruit helps to anchor it to the ground.

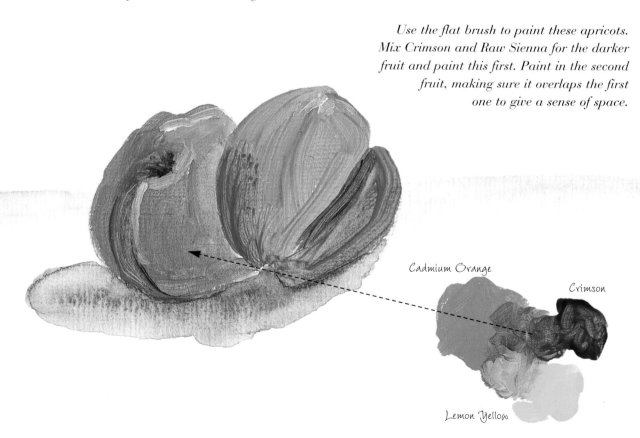

Use the flat brush to paint these apricots. Mix Crimson and Raw Sienna for the darker fruit and paint this first. Paint in the second fruit, making sure it overlaps the first one to give a sense of space.

Cadmium Orange

Crimson

Lemon Yellow

Bananas

With their slightly ridged shape, bananas are an easy fruit to start with. Try copying this one, then practise painting others from life. For all these studies, keep the initial drawing very simple, and concentrate instead on painting the basic shape then adding the details.

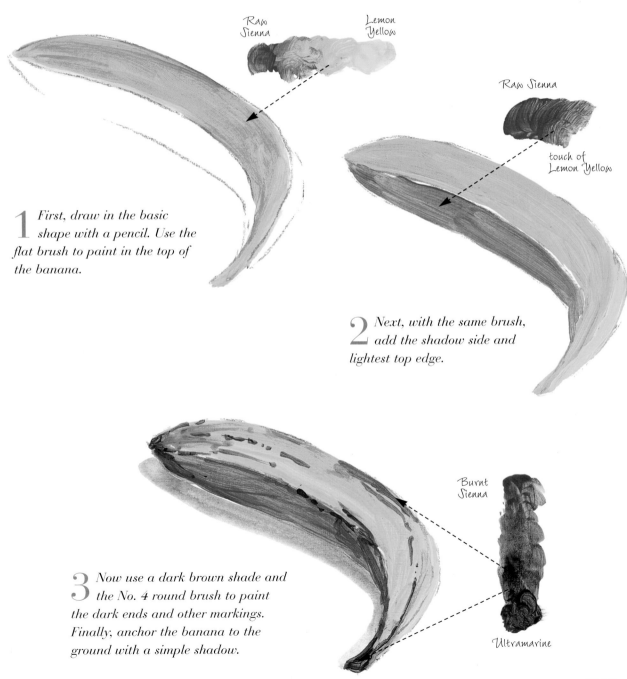

Raw Sienna

Lemon Yellow

Raw Sienna

touch of Lemon Yellow

Burnt Sienna

Ultramarine

1 *First, draw in the basic shape with a pencil. Use the flat brush to paint in the top of the banana.*

2 *Next, with the same brush, add the shadow side and lightest top edge.*

3 *Now use a dark brown shade and the No. 4 round brush to paint the dark ends and other markings. Finally, anchor the banana to the ground with a simple shadow.*

Pear

Here's another simple shape to try. This time I have added a yellow and white highlight to emphasize the smooth surface of the skin. See how the brushmarks help to give the pear its form and shape.

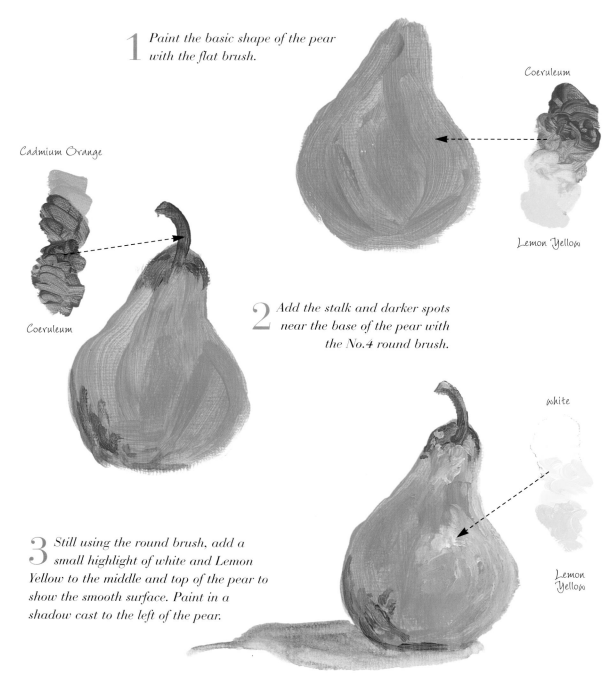

1 *Paint the basic shape of the pear with the flat brush.*

Coeruleum

Cadmium Orange

Coeruleum

Lemon Yellow

2 *Add the stalk and darker spots near the base of the pear with the No.4 round brush.*

white

Lemon Yellow

3 *Still using the round brush, add a small highlight of white and Lemon Yellow to the middle and top of the pear to show the smooth surface. Paint in a shadow cast to the left of the pear.*

Red grapes

These grapes are bit more complicated and you will need to draw them carefully first of all. Study them before you begin, and note how some grapes are partly hidden behind others. Where they overlap, the contrast of light against dark helps them to appear three dimensional.

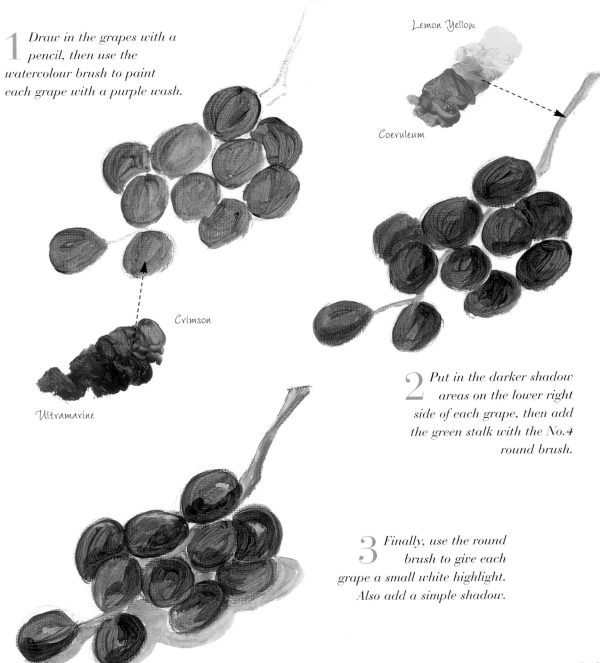

1 *Draw in the grapes with a pencil, then use the watercolour brush to paint each grape with a purple wash.*

Lemon Yellow

Coeruleum

Crimson

Ultramarine

2 *Put in the darker shadow areas on the lower right side of each grape, then add the green stalk with the No.4 round brush.*

3 *Finally, use the round brush to give each grape a small white highlight. Also add a simple shadow.*

EXERCISE Paint fruit

Now try painting several pieces of fruit together as a still life. See how I have arranged the fruit in my composition so that they overlap each other to create an impression of depth. Once you have followed my example, try some other combinations of your own, but keep it simple.

Coeruleum

Lemon Yellow

1 *Start by drawing the fruit with a 2B pencil. Then paint the green pear and the two bananas with the flat brush.*

Ultramarine

Crimson

2 *Use the No.4 round brush to paint a purple wash on the grapes before blocking in the rest of the bananas.*

The palette

Coeruleum

Lemon Yellow

Titanium White

Raw Sienna

Crimson

Burnt Sienna

Ultramarine

Burnt Sienna

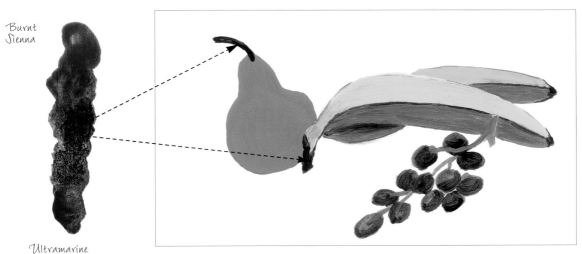

Ultramarine

3 *Using dark brown, add a stalk to the pear and mark in the dark ends and stripes on the bananas. Paint the green stalks on your grapes then add a shadow on each grape with a second wash of dark purple.*

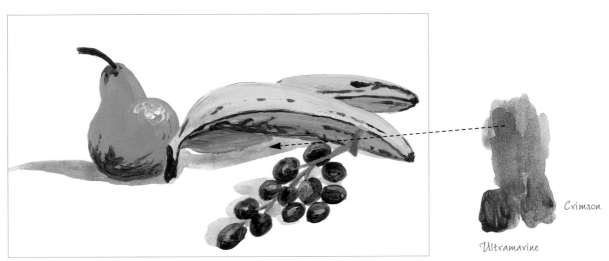

Crimson

Ultramarine

4 *Give the pear a dark shadow on the left-hand side and a yellow highlight on the top right and add a few extra marks to the bananas. Shadows anchor the still life to the ground.*

FLOWERS

Flowers are an especially cheerful and colourful subject. If you start by copying these studies they will give you the confidence to paint flowers from life. To keep things simple, use your brush to paint each petal rather than trying to draw the whole flower before you start. When you paint from life, choose simple flower shapes to begin with.

Daisies

Daisies are a favourite subject of mine, simple to paint and so charming whether in a vase or, as here, in a meadow. It is important to try to paint all flowers in the direction of growth. For these daisies I flicked the brush outwards from the centre of each flower to paint the overlapping petals.

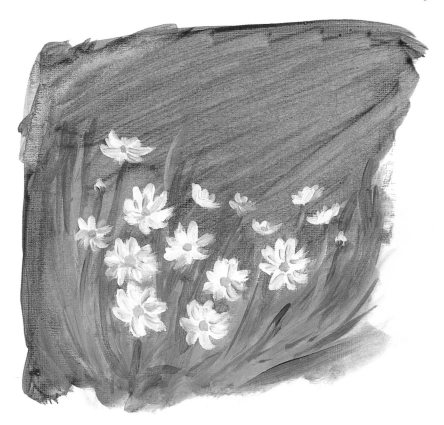

When painting white flowers it is obviously easier to have a coloured background rather than white paper. See how the thin washes I used for this study emphasize the thicker paint on the flowers themselves, making them stand out from the paper.

Tulip

Springtime bulbs are a welcome sight. I am especially fond of tulips with their bright colours and slender leaves. This one is yellow but you can use any colour you wish.

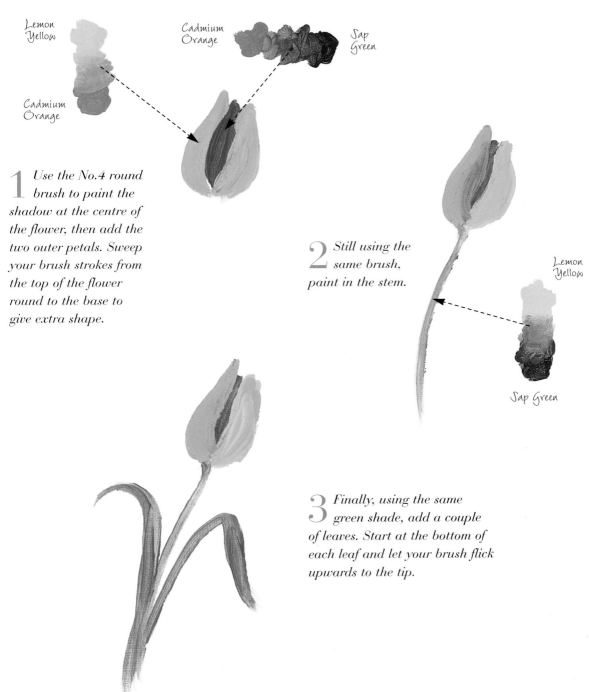

Lemon Yellow

Cadmium Orange

Cadmium Orange

Sap Green

1 *Use the No.4 round brush to paint the shadow at the centre of the flower, then add the two outer petals. Sweep your brush strokes from the top of the flower round to the base to give extra shape.*

2 *Still using the same brush, paint in the stem.*

Lemon Yellow

Sap Green

3 *Finally, using the same green shade, add a couple of leaves. Start at the bottom of each leaf and let your brush flick upwards to the tip.*

Sunflowers

Sunflowers are particularly easy to paint with acrylics. See how I have used single brush strokes for each petal to create the flower without any drawing.

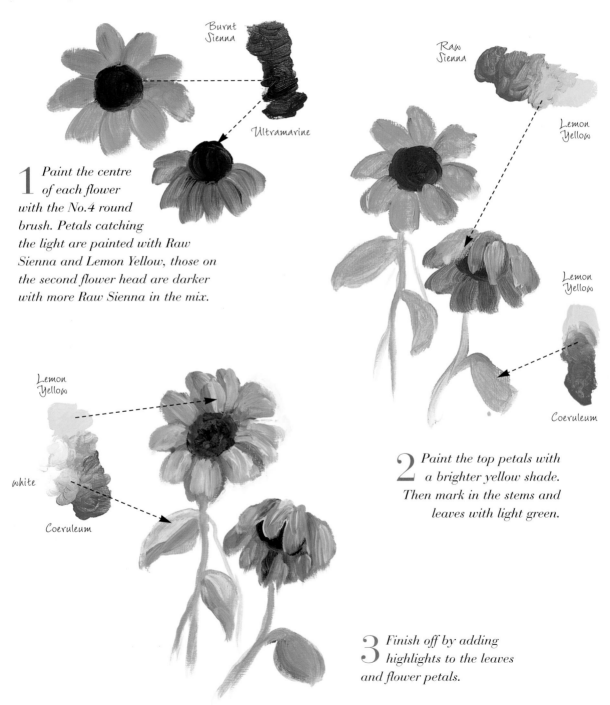

1 *Paint the centre of each flower with the No.4 round brush. Petals catching the light are painted with Raw Sienna and Lemon Yellow, those on the second flower head are darker with more Raw Sienna in the mix.*

2 *Paint the top petals with a brighter yellow shade. Then mark in the stems and leaves with light green.*

3 *Finish off by adding highlights to the leaves and flower petals.*

Poppies

Use the brightest of reds to paint these poppies. See how the flower bud is painted as a solid shape first, with its leaf wrapping added over the top, once the red has dried.

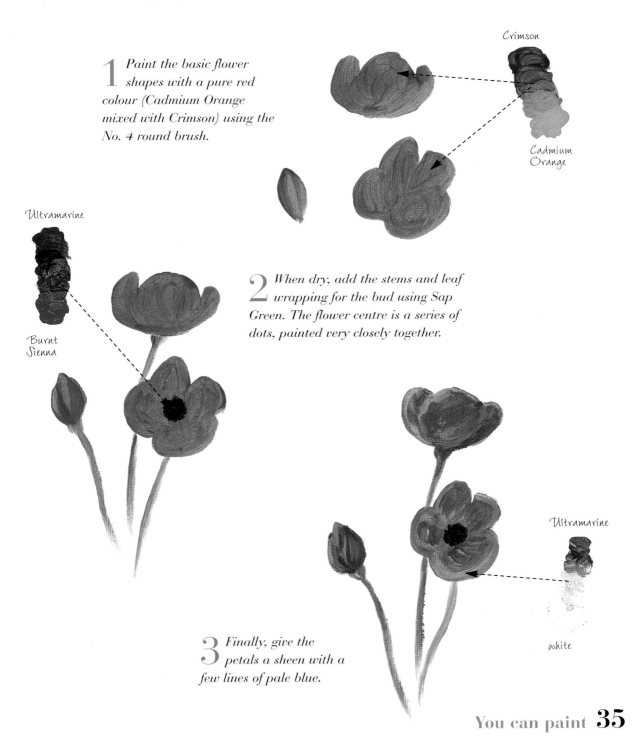

1 Paint the basic flower shapes with a pure red colour (Cadmium Orange mixed with Crimson) using the No. 4 round brush.

Crimson

Cadmium Orange

Ultramarine

Burnt Sienna

2 When dry, add the stems and leaf wrapping for the bud using Sap Green. The flower centre is a series of dots, painted very closely together.

Ultramarine

white

3 Finally, give the petals a sheen with a few lines of pale blue.

EXERCISE Paint sunflowers

Now try these sunflowers in a blue vase. The approach is the same for the blooms on page 34 only this time I have drawn in the composition first of all. Use the drawing as a rough guide to get you started rather than following it exactly.

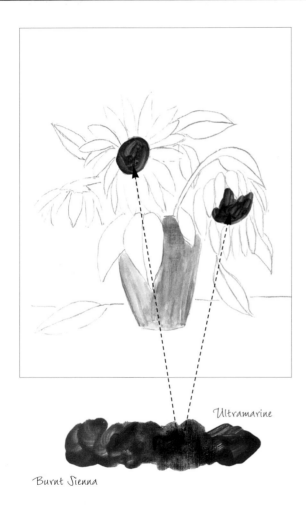

Ultramarine

Burnt Sienna

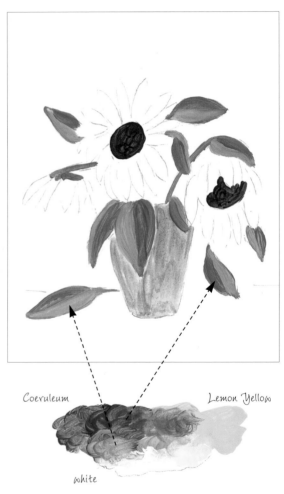

Coeruleum

Lemon Yellow

white

1 *Draw in the basic outline and then put a flat wash of Ultramarine over the vase. The sunflower centres are dark brown.*

2 *Paint the leaves with a No.4 round brush. Whilst still wet, lighten your green with a little white and paint the highlights on each leaf.*

The palette

Burnt
Sienna

Ultramarine

Coeruleum

Lemon
Yellow

Titanium
White

Raw
Sienna

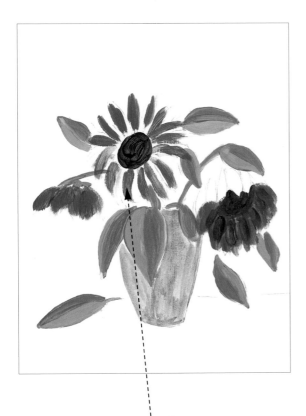

Raw Sienna

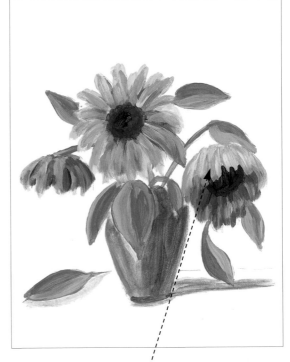

Lemon Yellow

white Raw Sienna

3 *Now for the petals. Start with Raw Sienna and paint all the petals in shadow, including shadows on the central flower.*

4 *Use bright yellow for the sunlit petals, and add a little white for the highlights, which can be as heavy as you wish.*

TREES

Trees bring variety and structure to the landscape, changing through the seasons from bright greens in spring to wonderful autumn golds and browns. To paint them well needs a little practice so start by looking at their overall shape before tackling foliage and other details.

Tree shapes

It is important that your trees look realistic, so observe the shapes of different types carefully. Here I have made a series of quick studies in paint, concentrating on the overall shape of each tree. Copy these first and then try a few of your own from life.

The character of this oak tree is easily captured in a few loose brushmarks. The few holes in the centre of the tree are particularly important.

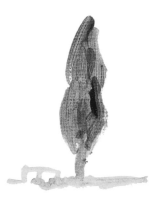

Move the brush upwards in the direction of growth to paint this tall poplar.

I used short, angled brushmarks to create this pine tree.

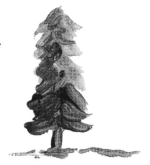

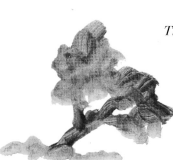

The pollarded willow leaning over was particularly easy to paint, as it has such a distinctive shape.

Distant trees

Trees in the distance are painted in a similar way to the shapes on page 38. Don't include any details in these studies, as you cannot see individual leaves from far away.

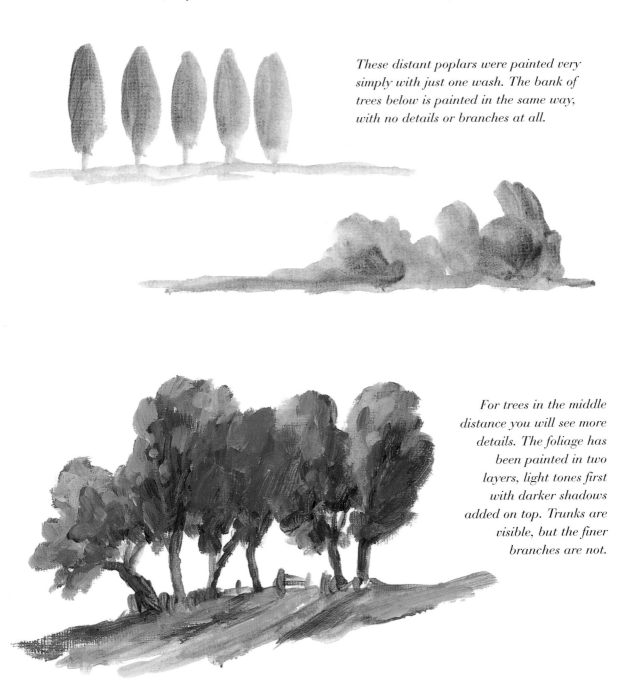

These distant poplars were painted very simply with just one wash. The bank of trees below is painted in the same way, with no details or branches at all.

For trees in the middle distance you will see more details. The foliage has been painted in two layers, light tones first with darker shadows added on top. Trunks are visible, but the finer branches are not.

Winter willow

In winter, when most trees lose their leaves, you can see the structure of the branches much more easily. This willow has a very distinctive shape and makes a good subject to begin with.

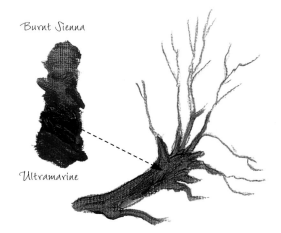

Burnt Sienna

Ultramarine

1 *Draw the trunk and main branches. Paint the trunk with the No.4 round brush.*

2 *Painting in the direction of growth, add the other main branches using the same dark brown.*

white

Ultramarine

Burnt Sienna

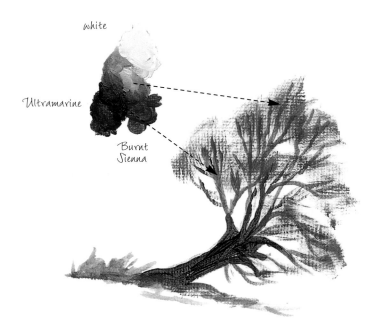

3 *Change to the flat brush and use the dry brush technique (page 15) to paint the outer branches and twigs.*

Sketching trees in winter

Choose a cold, sunny day to sketch winter trees, and remember to look for some of the details as well. A snowfall transforms the winter landscape. Look at the different shapes of snow-covered trees and make a few notes of any unusual colours you see.

Fir trees:
Note how the shadows within the snow help to enhance the sunlit patches on these firs.

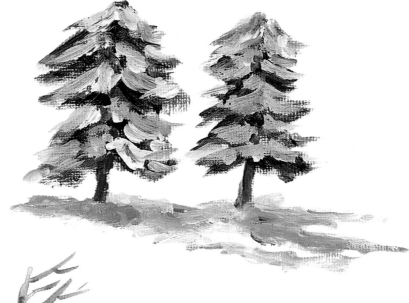

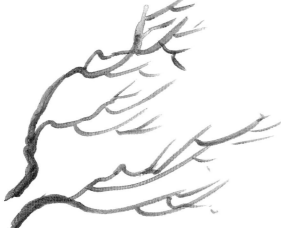

Branches:
These winter branches were painted with a No.4 round brush. Remember to work in the direction of growth and make the outer branches thinner.

Log:
This was painted with a flat brush, working darker tones wet-on-wet to give it a textured finish.

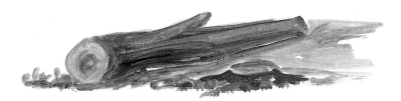

Spring tree

In spring, trees burst into flower and leaf. Colours are fresh and vibrant, making this a wonderful time to paint trees. This fruit tree with white blossom looks complicated, but starts in the same way as the winter tree (page 40).

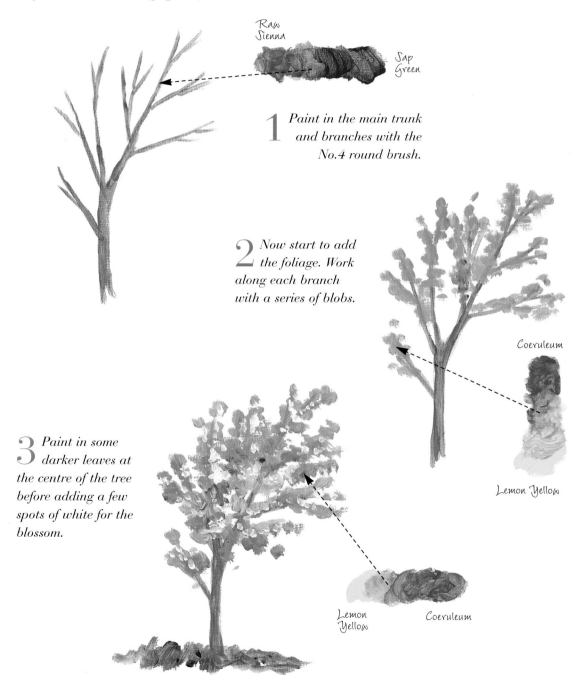

Raw Sienna

Sap Green

1 Paint in the main trunk and branches with the No.4 round brush.

2 Now start to add the foliage. Work along each branch with a series of blobs.

Coeruleum

Lemon Yellow

3 Paint in some darker leaves at the centre of the tree before adding a few spots of white for the blossom.

Lemon Yellow

Coeruleum

Sketching trees in spring

With so many fresh and vibrant colours in springtime, it can be difficult to decide what to paint first. Spring foliage can be quite acidic so use plenty of Lemon Yellow and Coeruleum when mixing these shades. Pink blossom can be painted using Crimson with a little white and Coeruleum.

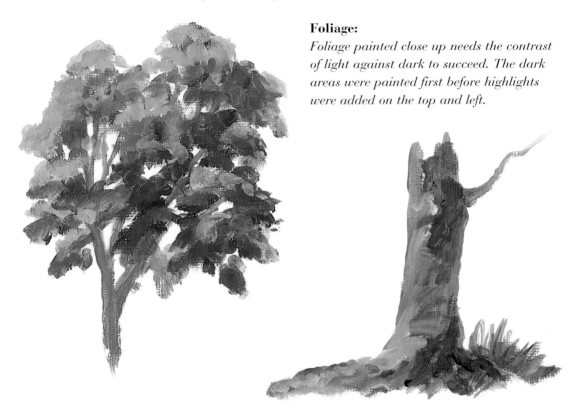

Foliage:

Foliage painted close up needs the contrast of light against dark to succeed. The dark areas were painted first before highlights were added on the top and left.

Trunks:

Tree trunks also need a light and dark side. Note how my brushmarks go across the trunk to give it more shape and texture.

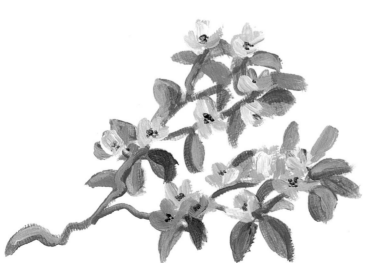

Apple branch:

The leaves on this apple blossom branch were painted using both light and dark greens to give them shape and form.

EXERCISE Paint autumn trees

As summer moves into autumn, so leaves turn to gold and russet making them very attractive to the artist. Have a go at painting this autumn tree, but take care to tone down your colours as I have done, otherwise they may look a bit too bright to be realistic.

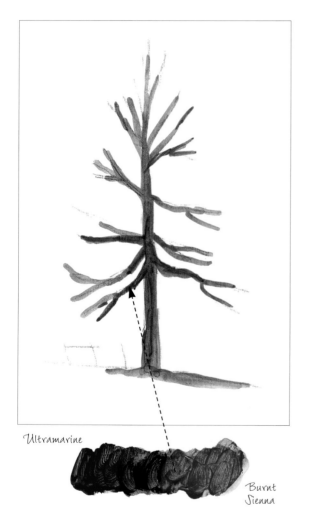

Ultramarine

Burnt Sienna

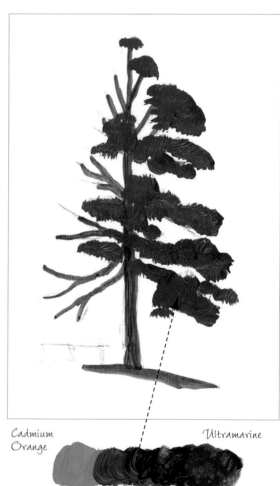

Cadmium Orange

Ultramarine

1 *Sketch the basic trunk and branches with a pencil. Then use the No.4 round brush to paint dark brown over your pencil lines. Add a little extra water for the paler outer branches.*

2 *Change to the flat brush and block in the darkest foliage on the right-hand side of the tree. Take care to leave plenty of open space between each patch of foliage at this stage.*

The palette

Ultramarine

Burnt
Sienna

Raw
Sienna

Cadmium
Orange

Titanium
White

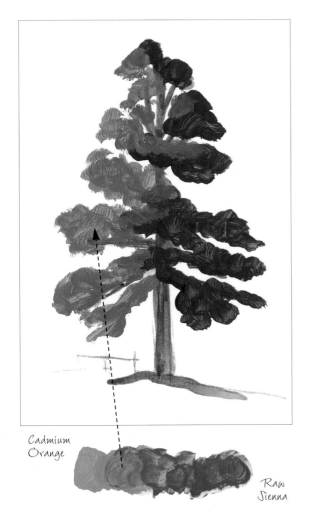

Cadmium
Orange

Raw
Sienna

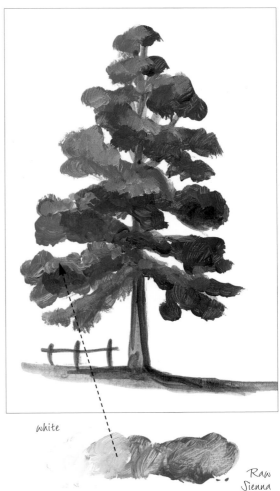

white

Raw
Sienna

3 *Add the lighter foliage to the left-hand side of the tree using the same technique but a much brighter gold shade, so that you have foliage over the whole tree.*

4 *Blend the two areas of foliage together, adding some highlights. Paint the fence dark brown before adding shadows on the trunk and beneath the tree with a purple wash.*

SKIES

Skies are the key element for landscape painting, as they set the mood and atmosphere. To paint skies well, you need to observe them carefully and practise sketching them at different times of the day. The more you paint skies, the easier they will become.

Cloudy sky

This study on a cloudy day was done very quickly, in about ten minutes. Note how I have painted the clouds larger in the foreground and smaller towards the horizon to help create a sense of distance. Always give your sky studies a horizon; this also helps create a sense of scale and distance.

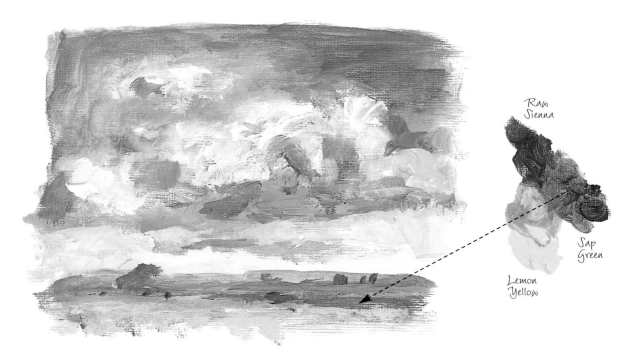

Raw Sienna

Sap Green

Lemon Yellow

First I painted the blue sky at the top with the watercolour brush, using Ultramarine and white, then added the darker cloud shadows.

Using the flat brush, I added the fluffy tops with much heavier patches of white impasto paint. A simple landscape gives a sense of scale.

Simple clouds

These fluffy summer clouds might look complicated at first but you will find them surprisingly easy if you paint them in stages as I have done here. Remember not to have a clear edge all the way round each cloud as this tends to make them float off the page and they will not look realistic.

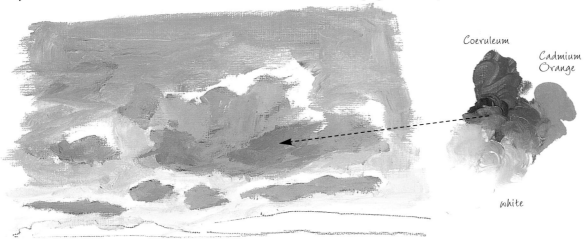

Coeruleum

Cadmium Orange

white

1 *Start at the top of the sky with a wash of Coeruleum and Ultramarine. Use plenty of water, but leave a ragged edge for the top of the clouds. Next paint in the shadow base of the clouds.*

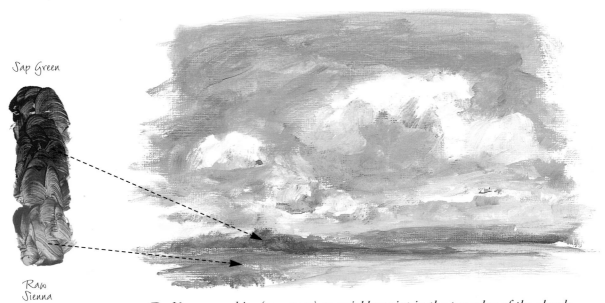

Sap Green

Raw Sienna

2 *Use pure white (no water) to quickly paint in the top edge of the clouds. The patch of sky beneath the clouds is a mix of Coeruleum, Lemon Yellow and white (turquoise hue). Finally, paint the horizon and distant hill.*

Sunset

Sunsets are exciting to paint, but you must take care not to use too many bright colours as this can make them look unrealistic.

1 *Use the watercolour brush to paint a wash of Coeruleum and Ultramarine, changing to Cadmium Orange halfway down. Then add a stripe of Ultramarine with Cadmium Orange beneath this for the sea.*

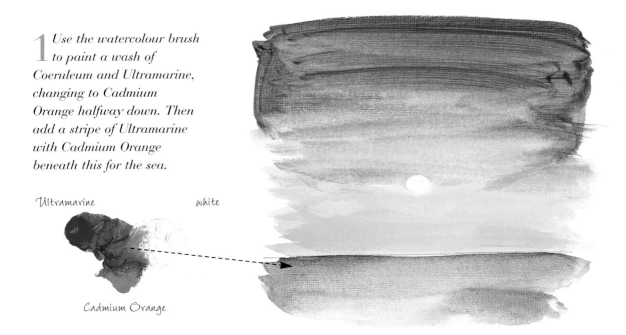

Ultramarine white

Cadmium Orange

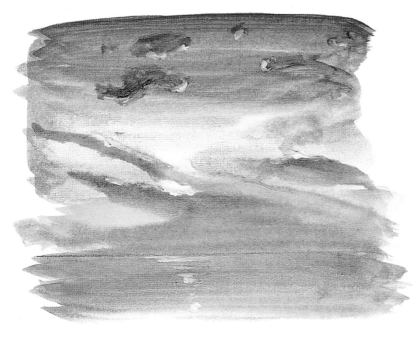

2 *Once the wash has dried, mix Coeruleum and Cadmium Orange for the clouds. Using the watercolour brush, mark in a few clouds towards the horizon. Keep these shapes fairly long with just a few smaller clouds above. Finally, load the flat brush with white and a little Cadmium Orange for the edges of the clouds and the reflection of the sun on the sea.*

Stormy sky

A stormy sky is very atmospheric. I have chosen dark purple tones for my storm clouds with varying amounts of white for the differing shades of grey.

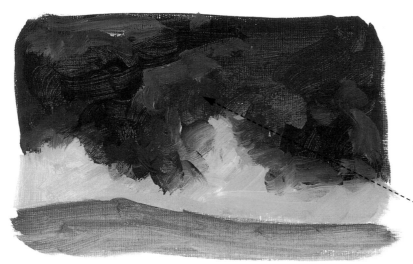

1 Start with Ultramarine and Crimson for the darkest clouds. Use the flat brush to scrub in rough shapes. Then use Sap Green and Raw Sienna for the hills beneath. The space between the storm cloud and the hills is painted using Raw Sienna and white.

Ultramarine white

Crimson

2 Next add the rain effect. Use the edge of the flat brush to paint thin lines of cloud colour coming out of the base of the cloud. Next use a little Lemon Yellow and white to add a highlight to the distant hill and also a few extra rain lines, and put in a streak of light from the centre of the storm cloud.

Sap Green

Raw Sienna

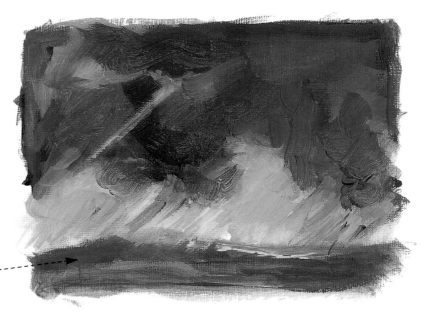

EXERCISE Paint a summer sky

These cumulus clouds are similar to those on page 47 but I have broken them down into more detail so you can really begin to understand how to paint them well. Once you have copied this exercise, try painting some clouds from life. It may help at first to work from photographs.

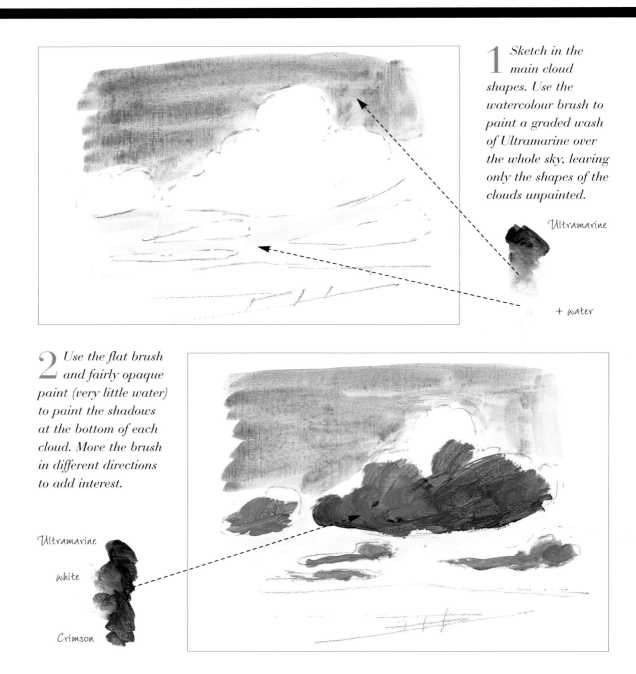

1 *Sketch in the main cloud shapes. Use the watercolour brush to paint a graded wash of Ultramarine over the whole sky, leaving only the shapes of the clouds unpainted.*

Ultramarine

+ water

2 *Use the flat brush and fairly opaque paint (very little water) to paint the shadows at the bottom of each cloud. Move the brush in different directions to add interest.*

Ultramarine

white

Crimson

The palette

Ultramarine Crimson Sap Green Raw Sienna Titanium White

3 *Now put in the horizon with its distant hillside to give a sense of scale.*

Ultramarine

white

Sap Green

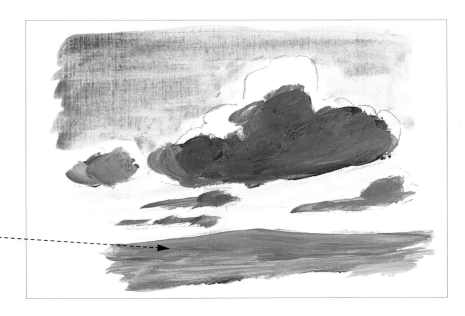

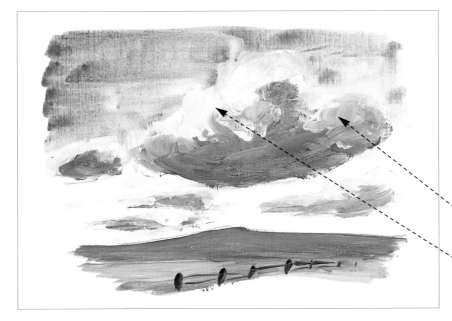

4 *Paint the tops of each cloud with a pale cream and white. Load the brush with paint (no water) and let the brushmarks show to give texture and movement. The thicker the paint the better!*

Raw Sienna

white

WATER

Water can be very effective in any picture, whether you are painting a calm lake with mirror-like reflections, or rough water, or waves breaking onto a beach. In order to paint water and reflections well, you will need to learn several different but very simple techniques.

Calm water

Where there is water, you will often find boats, and the reflections they make add movement and colour to any painting. The reflections only disappear completely if the water is very rough.

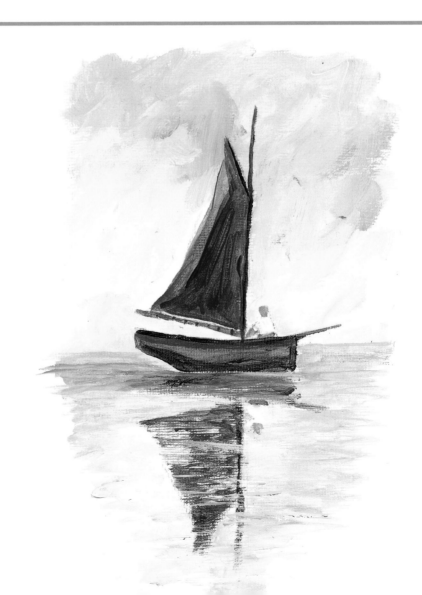

The reflections of this sailing dinghy were painted with horizontal brush strokes dragged across the paper. Note how the angle of the sail is opposite to that of its reflection.

Simple reflections

Before we look at painting water in detail, let's see how to paint simple reflections. In each case I have not painted the water at all, just the reflection.

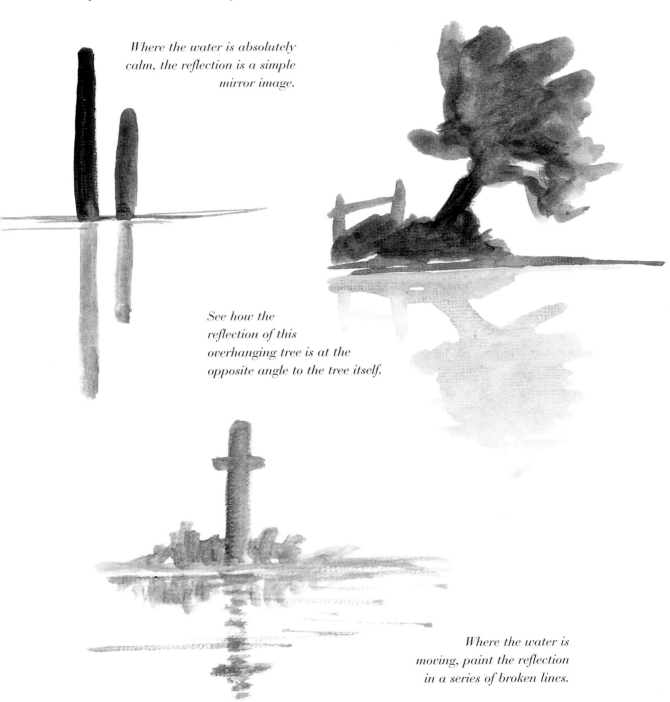

Where the water is absolutely calm, the reflection is a simple mirror image.

See how the reflection of this overhanging tree is at the opposite angle to the tree itself.

Where the water is moving, paint the reflection in a series of broken lines.

Still water

Still-water reflections are perhaps the easiest of all to paint. Try this study of overhanging willow trees. The reflections are painted as flat washes rather than brush strokes.

1 *Use the No.4 round brush to paint the trees and the land behind. Then use the watercolour brush to paint the reflections underneath with a soft grey shade (Cadmium Orange with Ultramarine and plenty of water).*

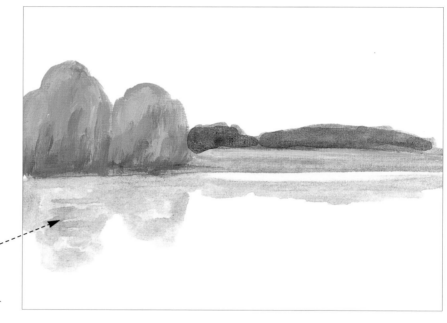

Ultramarine

Cadmium Orange + water

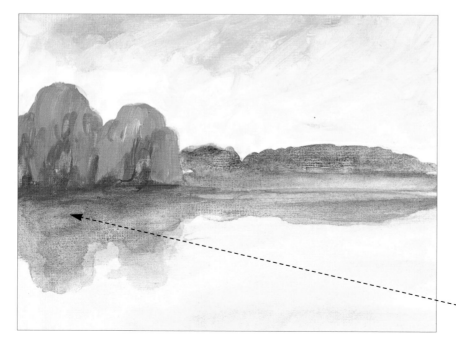

2 *Next, paint the sky with Coeruleum and white. Put a wash of the same sky tone over the whole of the water, going over your existing tree reflection. Whilst still wet, add a little green shade (Coeruleum, Lemon Yellow and white) to the willow reflections to strengthen them.*

Lemon Yellow Coeruleum

white

Moving water

Painting moving water requires a somewhat different approach. Here there are no reflections at all, so you just paint the waves created by the wind on the water surface.

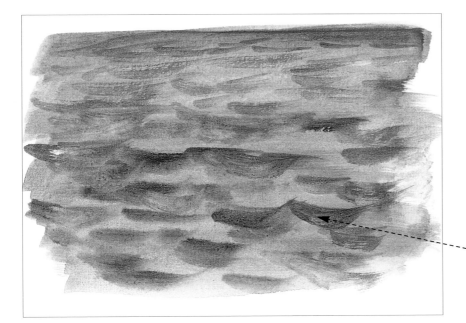

1 *Using the watercolour brush, paint a flat wash of Ultramarine. Whilst still wet, paint the waves with more Ultramarine, darkened with a little Cadmium Orange.*

Ultramarine

Cadmium Orange

2 *Let this dry then, using the No.4 round brush, paint the highlights on each wave with a little pure white (no water added).*

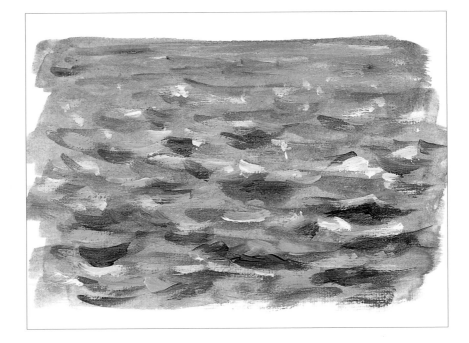

Distorted reflections

Having looked at how to paint reflections in still water and also how to paint moving water, we can now combine these two techniques to paint reflections in rippling water, for example, where a breeze has distorted the reflection without it disappearing altogether.

1 *Use the flat brush to paint the background hills and meadow. Use lively brush strokes for the tree, adding more yellow to your green mixture for the highlights. Use the same brush to paint the water a solid area of pale blue (Ultramarine and white).*

Lemon Yellow

Sap Green Ultramarine

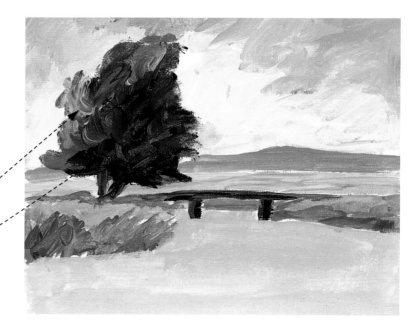

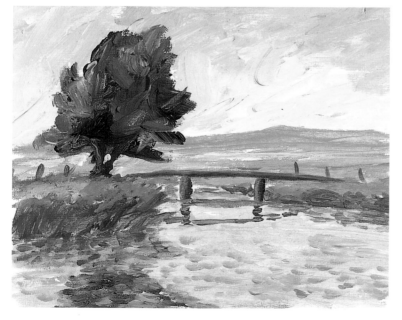

2 *Use the edge of the flat brush to paint in the waves which make up the reflections. Use Raw Sienna for the reflected meadow and a dark green for the tree. Add some darker blue waves in the middle of the river for extra movement.*

Breaking wave

This exercise shows you how to paint a breaking wave. Copy it careful and practise painting as many waves as you can. Once you have mastered this lesson you will have the confidence to tackle the beach demonstration on pages 88–91.

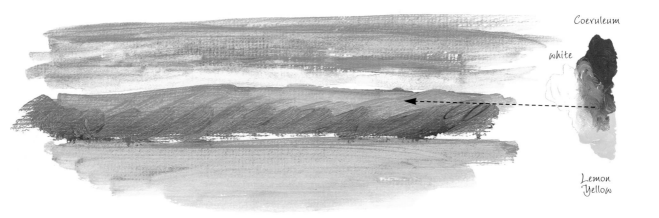

Coeruleum

white

Lemon Yellow

1 Mix Coeruleum, Lemon Yellow and white and paint in the back of the wave with the flat brush. Add a darker band of colour towards the bottom of the wave. Next, paint a flat wash of Raw Sienna for the beach, ensuring it goes right to the base of the breaking wave.

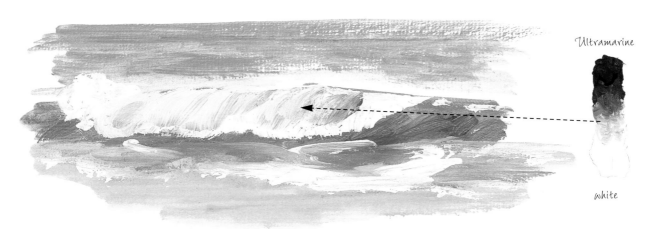

Ultramarine

white

2 Whilst still wet, load the flat brush with white paint and add the breaking surf. Put a few swirls of white over the beach at the same time. Add a little Ultramarine shadow: this helps to show the downward movement of the breaking water.

AT A GLANCE...

 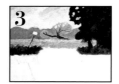 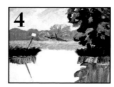 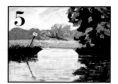

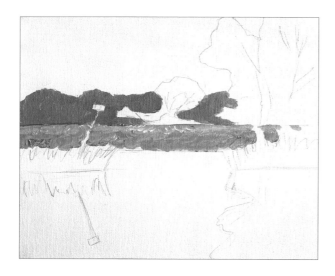

1 *Start by drawing in the main elements with a 2B pencil. Paint the far bank of trees first with a pale grey shade (Ultramarine, Sap Green and white) using the flat brush. Avoid painting over the middle-distance fallen tree. Next use Lemon Yellow, Raw Sienna and white to paint the meadow. Short, vertical brush strokes with the full side of the flat brush will help to give this area some texture.*

2 *Use the No.4 round brush to paint the fallen tree with Lemon Yellow, white and Raw Sienna, and use Sap Green and Raw Sienna for the main tree. Add reeds with Burnt Sienna. Make sure this stage is dry before moving on.*

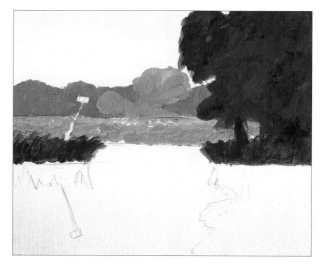

The palette

Sap Green

Ultramarine

Titanium White

Crimson

Lemon Yellow

Raw Sienna

Burnt Sienna

3 Now for the sky. Use the watercolour brush loaded with paint but very little water. Start with Ultramarine and white, adding Crimson for the clouds and blending down to white and Raw Sienna at the horizon. Change to the No.4 round brush and paint in a few sky holes over the dry green of the main tree. Put in the post and a few branches on both trees with Burnt Sienna and Ultramarine.

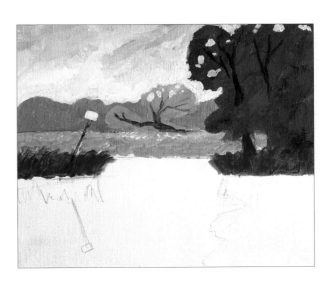

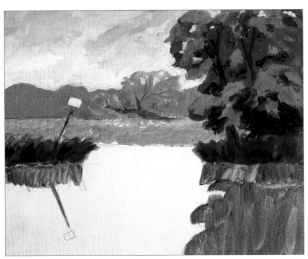

4 To finish off the trees, paint highlights using the flat brush – Lemon Yellow and white for the middle tree, Sap Green and white for the main tree. Using the watercolour brush, paint in the reflections – Sap Green and Raw Sienna for the tree, Burnt Sienna for the reeds. Keep your brush strokes vertical for the reflections.

5 *Finished picture:* Canvas board, 25 x 30 cm (10 x 12 in). The rest of the water can now be painted with a pale blue (white and Ultramarine), before adding the surface ripples. To paint the ripples, use the edge of your flat brush loaded with the same blue, and drag it over the reflections. Use a slightly darker blue for ripples in the middle of the river.

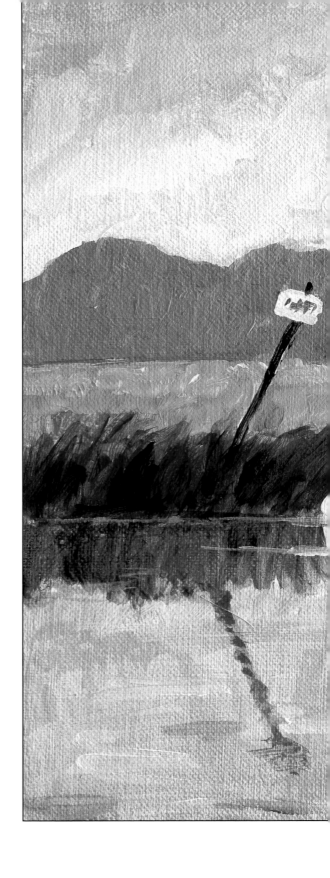

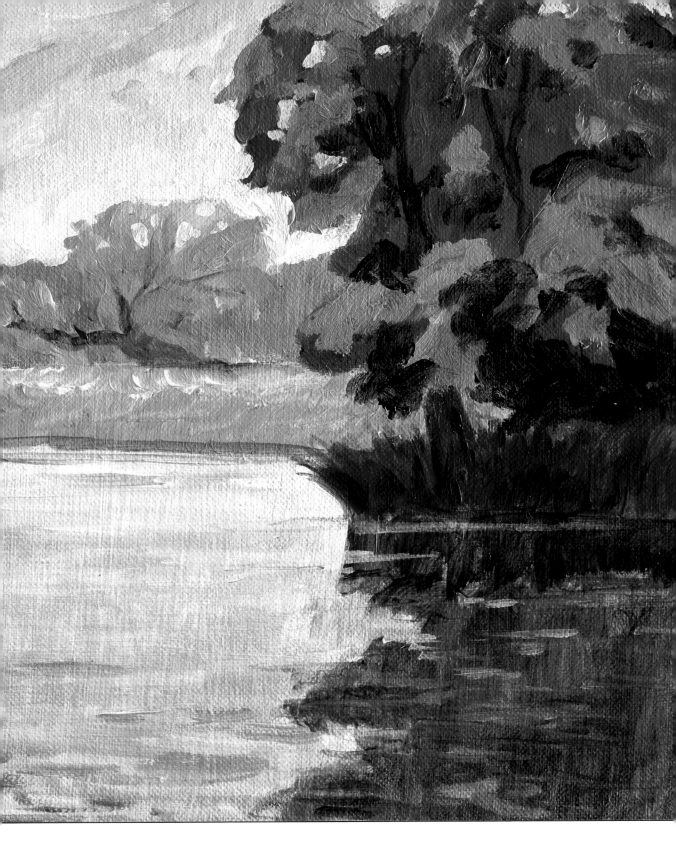

BUILDINGS

When you start to paint buildings it is helpful to think of them as simple shapes. All buildings are basically box shapes (similar to the cube on page 24) so breaking each building down into a number of simple blocks will help you to start painting buildings with confidence.

Fisherman's cottage

See how I have simplified this fisherman's cottage into two shapes, a box for the cottage and a triangular lid for the roof. Try to imagine each building you paint as separate blocks.

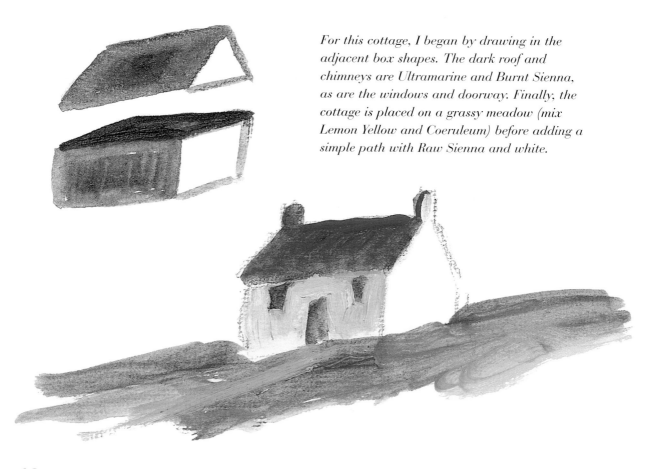

For this cottage, I began by drawing in the adjacent box shapes. The dark roof and chimneys are Ultramarine and Burnt Sienna, as are the windows and doorway. Finally, the cottage is placed on a grassy meadow (mix Lemon Yellow and Coeruleum) before adding a simple path with Raw Sienna and white.

Buildings in silhouette

Another way to simplify buildings, even a whole row of houses, is to paint them in silhouette. The lack of details on silhouetted buildings also helps them to merge into the background, making this a useful approach when trying to create more depth in your paintings.

When painting these buildings, you need to concentrate on getting the line of roofs right. Don't forget to add the chimneys!

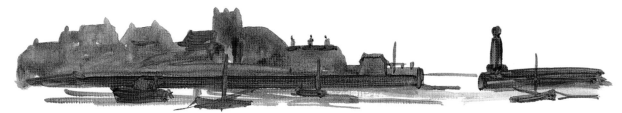

Simple perspective

When we look at objects, lines above our eye level, such as the roof on a building, appear to angle downwards into the distance towards the level of our eyes, whereas items below this line, such as a road or footpath, appear to move upwards. The effect is the same in a painting, except that the eye-line is replaced by the horizon line.

In this diagram I have put in a single horizon line. See how the roof of the house (above the horizon) falls slowly downwards to a vanishing point in the far distance. Similarly the sides of the box which is below the horizon are angled upwards to a different vanishing point.

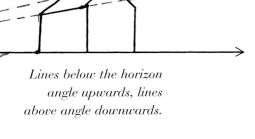

Lines below the horizon angle upwards, lines above angle downwards.

Pink cottages

These cottages are similar to the fisherman's cottage on page 62. See how to begin with I have broken them down into a simple oblong with a roof. Windows and doorways are added later.

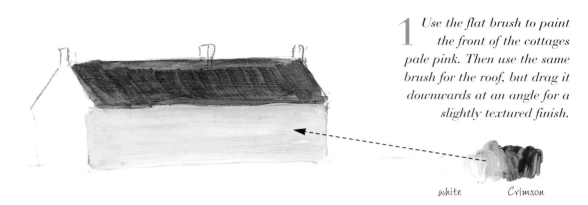

1 *Use the flat brush to paint the front of the cottages pale pink. Then use the same brush for the roof, but drag it downwards at an angle for a slightly textured finish.*

white Crimson

2 *Paint the windows and doorways in dark grey with the No.4 round brush. The end wall of the cottages is very pale pink rather than pure white.*

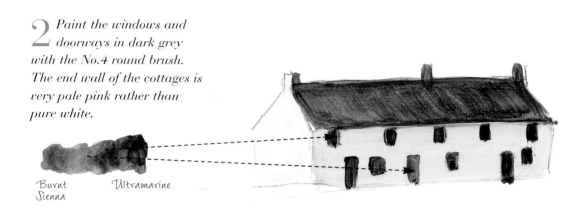

Burnt Sienna Ultramarine

3 *Anchor the cottages to the ground with a purple wash. Paint a shadow under the eaves. Finally, paint the doors and shutters on the windows with Coeruleum.*

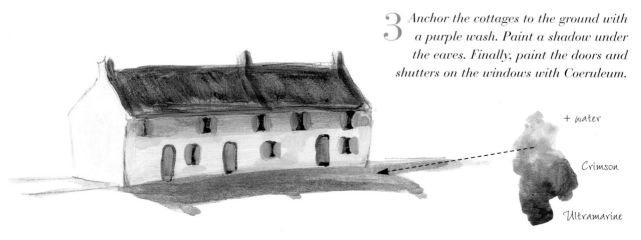

+ water

Crimson

Ultramarine

Church

There are a few more shapes to consider for this village church. Start by looking for the main block shapes before concentrating on the details.

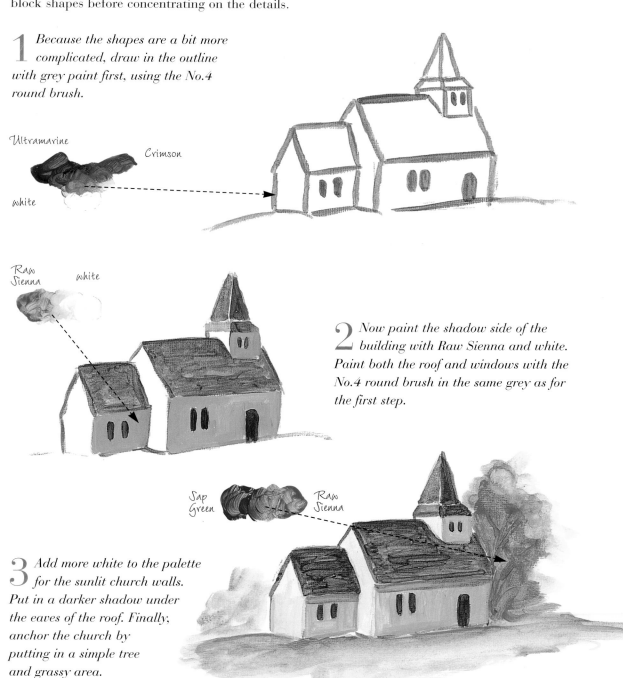

1 *Because the shapes are a bit more complicated, draw in the outline with grey paint first, using the No.4 round brush.*

Ultramarine

Crimson

white

Raw Sienna

white

2 *Now paint the shadow side of the building with Raw Sienna and white. Paint both the roof and windows with the No.4 round brush in the same grey as for the first step.*

Sap Green

Raw Sienna

3 *Add more white to the palette for the sunlit church walls. Put in a darker shadow under the eaves of the roof. Finally, anchor the church by putting in a simple tree and grassy area.*

DISTANCE AND FOREGROUND

Subjects in the distance appear smaller and have less detail so it is important to remember this when you are painting them. Another rule which will help you to create a sense of distance in your paintings is that cool colours, such as blues or mauves, recede, whereas warm colours. such as strong reds and yellows, tend to come forward.

Distant village

This painting of a French village uses several techniques to create a sense of distance. Firstly, the far hills are painted in a cool blue shade. The buildings have been treated very simply without much detail, and both the road and line of trees help guide the eye into the painting. Note also how the tops of the trees angle downwards towards the horizon. This also helps create depth in the picture.

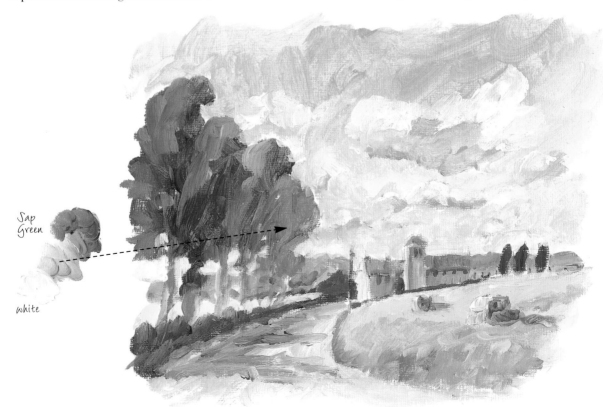

Sap
Green

white

Distant hills

This simple landscape is painted using warm and cool tones to show just how effective warm and cool shades can be in creating distance.

1 *Paint the sky with Ultramarine and white, using the flat brush. Use the watercolour brush to paint a purple wash (Ultramarine and Crimson) for the distant hill. Overlap this with a darker wash for the second hill.*

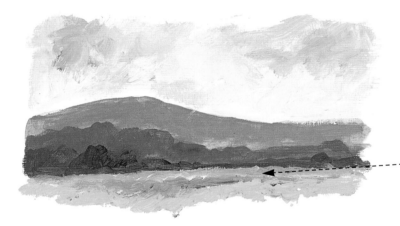

2 *Add a little Raw Sienna and paint a third hill before using Raw Sienna and Lemon Yellow for the foreground meadow.*

Raw Sienna

Lemon Yellow

3 *Lastly, put in the poplar trees and fence posts on the left to lead your eye into the painting.*

Ultramarine

Sap Green

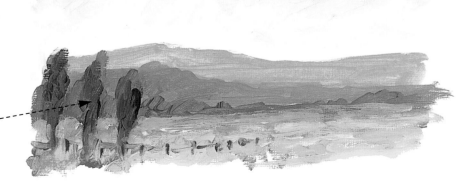

Foreground details

Another way to create depth within your paintings is to include more details in the foreground. But you must keep these details in the foreground otherwise you risk losing the depth created by having a simplified background. It is all a matter of balancing techniques.

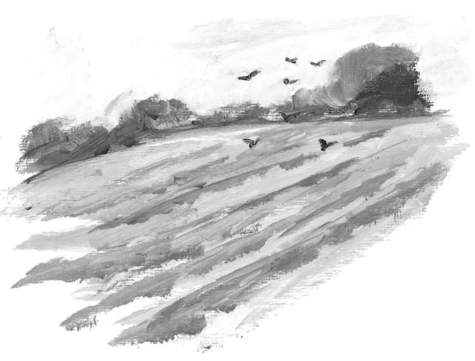

A ploughed field makes a good foreground. See how the lines lead your eye naturally into the painting to help give a sense of depth and distance.

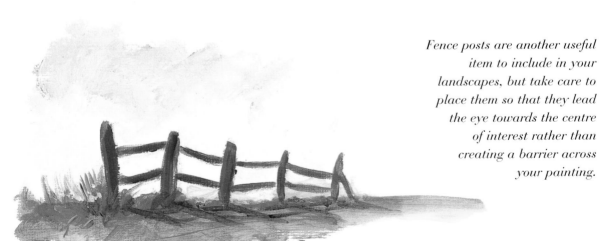

Fence posts are another useful item to include in your landscapes, but take care to place them so that they lead the eye towards the centre of interest rather than creating a barrier across your painting.

Sketching landscape details

Here are some more ideas for landscape details that you can include in your paintings. All these items are simple to paint but will help to bring your paintings to life as well as making them appear more complicated than they really are.

Puddles:
These puddles are patches of very pale blue (reflecting the sky) painted over a muddy lane.

Rocks:
Paint rocks and pebbles with a dark shade first, then add a few highlights to the top of each one to bring them to life.

Grass:
Tufts of grass are easy to paint. Load the No.4 round brush with paint and flick each brush stroke gently upwards.

Stone wall:
Stone walls need a little more effort. First paint the whole wall dark grey; then use the No.4 round brush to paint in each stone with a paler grey, just like building a real wall!

DEMONSTRATION MOUNTAINS

AT A GLANCE...

1

2

3

4

5

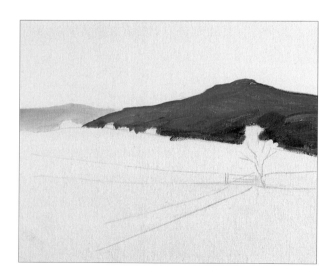

1 Use your 2B pencil to draw this landscape but don't put in too much detail. Paint a pale purple wash (Ultramarine, Crimson and white) with your flat brush over the distant hill. Darken this mix and add a little Sap Green before using it to paint in the main hill.

2 Next, mix pale green using Lemon Yellow, Coeruleum and white for the middle-distance field. Apply the paint fairly thickly using diagonal brush strokes with the No.4 round brush to create a sense of distance. The foreground field is a mix of Raw Sienna and Coeruleum, with a little Lemon Yellow for a warmer green. Use more random brush strokes for the foreground to give a textured feel to the grass.

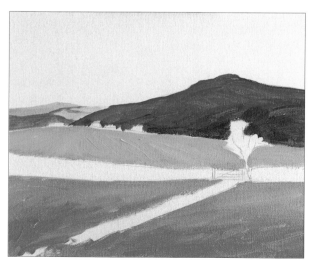

The palette

 Ultramarine

 Crimson

 Titanium White

 Sap Green

 Lemon Yellow

 Coeruleum

Raw Sienna

Cadmium Orange

 Burnt Sienna

3 *Using the watercolour brush, mix Ultramarine and white (with a touch of Cadmium Orange) and paint in the sky, starting at the top of the picture. Add a little Raw Sienna towards the horizon. The cloud tops are pure white with a pale grey underneath (Ultramarine, Cadmium Orange and white). Add a few highlights on the big hill to help give it extra shape and form (white, Raw Sienna and Sap Green).*

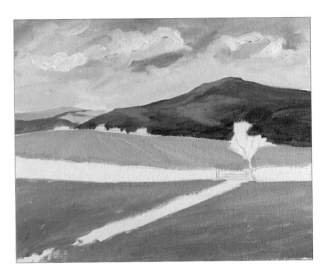

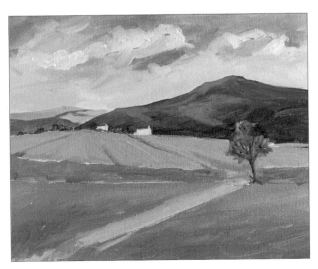

4 *Mix a grey for the stone walls (white, Coeruleum and Cadmium Orange). With the flat brush, paint the distant walls as solid lines. Darken your mix slightly to paint the foreground wall. Paint the path in the same way, but use Raw Sienna and white. Distant cottages are white with Burnt Sienna for the roofs. Use the No.4 round brush to paint the right-hand tree. Its trunk and branches are dark brown (Burnt Sienna and Ultramarine), leaves are Sap Green and Cadmium Orange. Use this same green for the trees behind the white cottages.*

5 *Finished picture: Canvas board, 25 x 30 cm (10 x 12 in). Now for the details that bring the scene to life. Start with the cottages using the No.4 round brush. A single brush stroke is enough for each window and doorway. Next use a pale grey (Coeruleum, Cadmium Orange and white) for the stones in the foreground wall. Each stone is a single brushmark. Use the same grey to paint some pebbles alongside the path, before adding a few tall grasses behind them (with Sap Green and Cadmium Orange). Finally, paint the gate in darkest grey with the No. 4 round brush.*

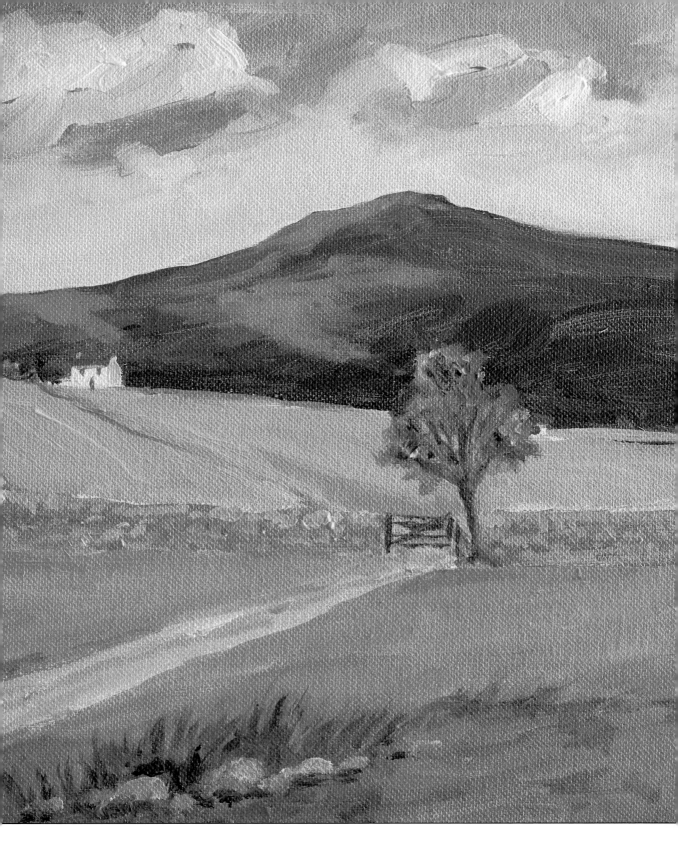

PEOPLE AND ANIMALS

At some stage in your development as an artist you will probably wish to include figures and animals in your paintings. These do not need to be finished portraits. A simple study, without any facial details, can look really effective. People and animals can add life and movement to your paintings.

Simple figures

Let's look first of all at simple figures suitable for placing in the middle distance of a painting. In every study here you will find just enough detail to capture the movement and character of the person without any unnecessary extras. Rather than trying to draw an accurate outline, I always start with a body as a solid shape, adding head, legs and arms, a bit like painting a stick figure.

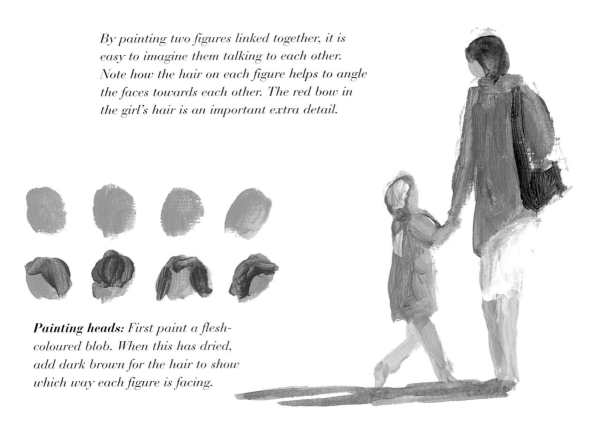

By painting two figures linked together, it is easy to imagine them talking to each other. Note how the hair on each figure helps to angle the faces towards each other. The red bow in the girl's hair is an important extra detail.

Painting heads: *First paint a flesh-coloured blob. When this has dried, add dark brown for the hair to show which way each figure is facing.*

Sketching figures

Painting figures should be fun, so here are a few tips to get you started. See how the figures are painted very loosely and simply with no facial details. Start with the body, painting the clothes rather than the figure underneath. Arms and legs are often single brush strokes with flesh-coloured blobs for hands.

Moving figures:
To help give your figures movement, don't paint the feet. Where I have put in feet, they give the figure a comical look and lose the sense of movement.

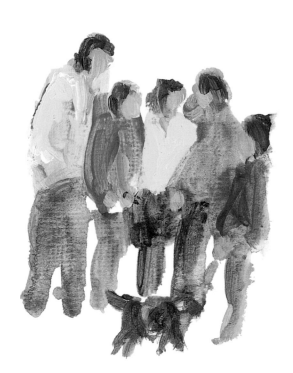

Group of people:
See how easy it can be to turn a series of blobs into a group of figures, simply by adding heads and legs.

Adult figure

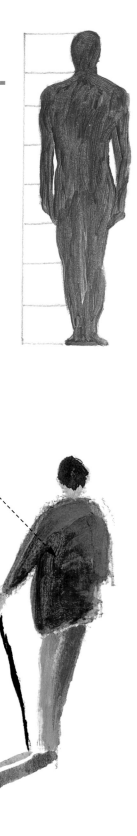

If you study people as they walk, you will see how one leg disappears from view as they step forward. If you show this in your painting it will help to create a sense of movement in your figures. It is vital to get the proportions of your people right. For adults, the total height is 8 times the head height.

1 First, draw your basic figure in pencil. Then paint the red jacket with Crimson, and the disappearing leg with Ultramarine.

2 Now paint the second leg in full, using a paler blue (add a little white to your palette). Do the legs move? Use a flesh tone for the head and hand, then paint the walking stick dark brown.

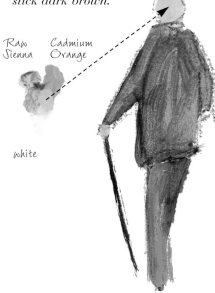

Raw Sienna Cadmium Orange

white

Crimson

Sap Green

3 Give your figure some hair, then add dark red shading to the jacket. Finally, put in a shadow to anchor your figure to the ground. Don't forget to give the walking stick a shadow.

Children

To make children look realistic and to avoid painting small adults, remember that the proportions are different from those of adults – a toddler will be 4 heads high and a young child (around 9 years old) 6 heads high. This difference in scale is the key to painting children successfully.

Toddler is 4 heads high.

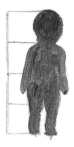

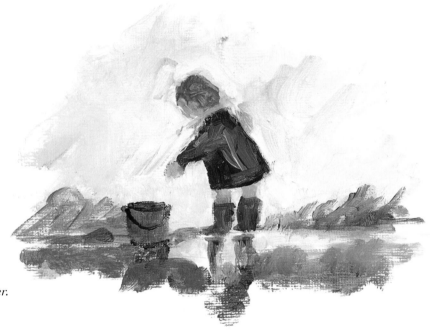

Wellington boots on this toddler help to bring out his character.

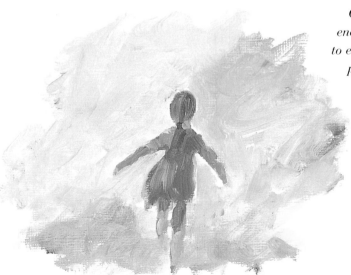

Children are full of energy and life so try to express this in your paintings. To make the girl appear to be running, paint one leg much shorter than the other.

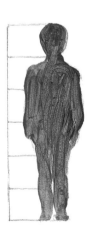

Older child is 6 heads high.

Dogs

Just as you will want to include people in your paintings, so it is fun to paint animals. Dogs are an obvious favourite. If you own a dog, you already have a model: if not, start with this example.

1 Use the No. 4 brush and start by painting a cube for the head and oblong for the body of each dog in Burnt Sienna.

 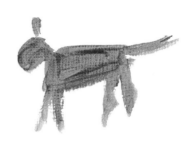

2 Next, fill in the body shapes, adding the legs, ears and tails.

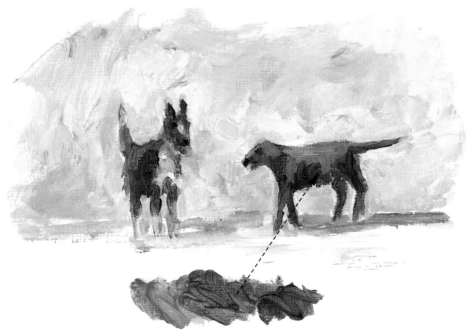

3 Add shadows to give shape to the body of each dog. Paint white fur on the neck of the left-hand dog to help bring him to life. Any unwanted edges can be sharpened up by painting in the background with Ultramarine and white.

Burnt Sienna Ultramarine

Horse

Painting a horse is more complicated so you will need to concentrate to get this one right. See how I have painted in a background to cover any unwanted lines or rough edges on my finished horse.

1 *Take the No.4 round brush and paint a series of oval shapes for the body – draw this stage in pencil first if you prefer.*

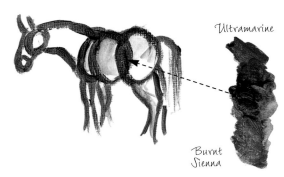

Ultramarine

Burnt Sienna

Ultramarine

white

Burnt Sienna

2 *Use black and white to paint the whole body. Note how the legs on the far side are a shadow grey tone.*

3 *Add the mane and tail with white paint before putting a little shadow colour around the hindquarters to give the horse more form and shape. Finish the background to give the horse a sharp outline.*

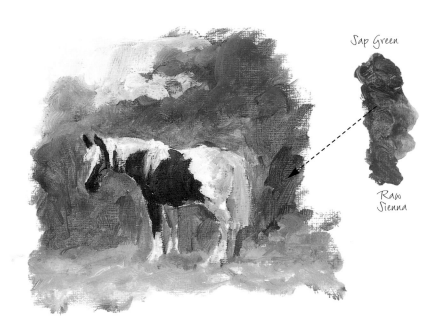

Sap Green

Raw Sienna

EXERCISE Painting people

These two boys fishing over a harbour wall in France made an interesting subject for a study. I particularly liked the way their fishing rods crossed over each other, and their intense concentration – I don't think they realised I was sketching them at the time.

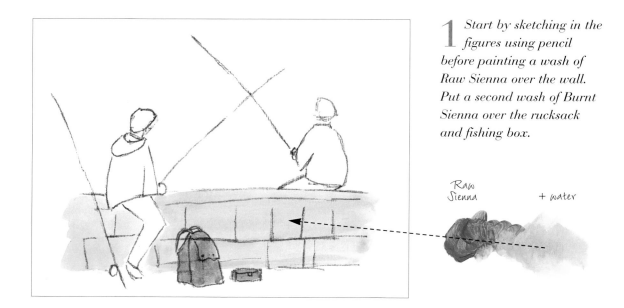

1 *Start by sketching in the figures using pencil before painting a wash of Raw Sienna over the wall. Put a second wash of Burnt Sienna over the rucksack and fishing box.*

Raw Sienna + water

2 *Use the No.4 round brush to paint the clothes on each figure as flat colours before painting in the fishing rods with a dark grey.*

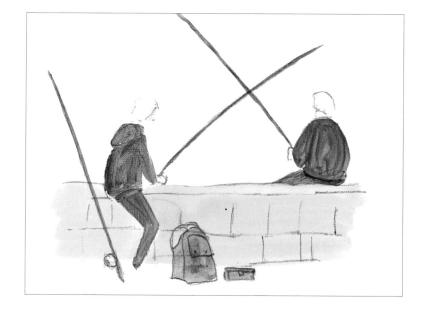

The palette

 Raw Sienna

 Burnt Sienna

 Titanium White

 Ultramarine

 Sap Green

 Cadmium Orange

 Crimson

3 *Paint hands and heads on your figures with a basic flesh tone. Add a shadow to the rucksack and box using a second layer of Burnt Sienna. Add cracks in the wall in pure Raw Sienna. Draw in the fishing lines with a pencil.*

Cadmium Orange

Raw Sienna white

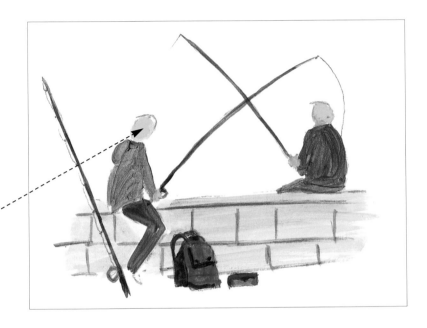

4 *Give each figure some hair, making sure each boy is looking towards his own fishing rod. Then add the shadows, on the boys' jackets, the wall and in the foreground.*

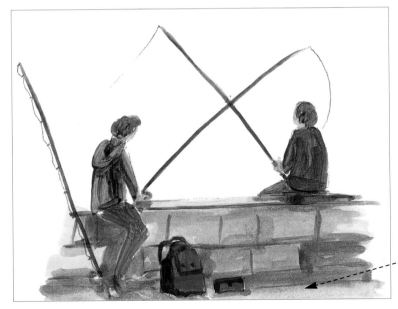

+ water Crimson

Ultramarine

Seaside

The beach is a wonderful place to paint. Families will often stay in one place all day, giving you plenty of time to practise painting them. Take a sketchbook as well as your paints and you can settle down for a whole day. Make several studies rather than trying to produce one finished painting.

Girl on beach

This young girl at the beach with her fishing net caught my eye as a good subject to paint. Note how the reflection on the wet sand is softer and more subtle than it would be in water. A series of squiggles is all that was needed here.

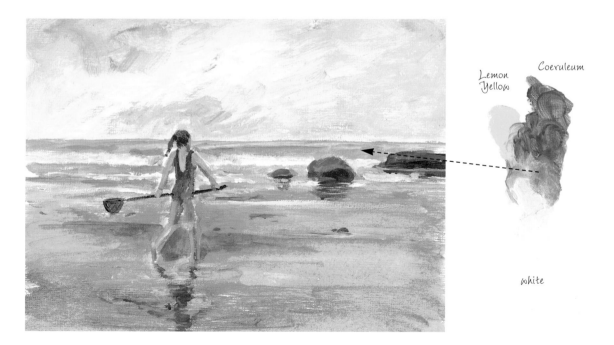

I put the figure in first of all, using Cadmium Orange, Raw Sienna and white for the flesh tones, and Coeruleum for the swimsuit. I kept the overall composition of the beach simple with just a few rocks and reflections so as not to detract from the main subject, the girl.

Sketching at the seaside

With so many subjects to choose from at the seaside, it can be hard to decide where to start. It is a good idea to make lots of small sketches rather than just one painting. Here are some suggestions to help you.

Sand castle:
Sand castles always bring back fond childhood memories. The flags add both colour and movement.

Shell:
Here I used clearly defined brushmarks for the highlights on this shell to give it a rough texture.

Bucket and spade:
There are usually plenty lying around! See how the shadow on the back of the spade gives it form.

Boats

There are always plenty of boats at the seaside. Look for simple shapes first of all and avoid putting in too much detail. If you still find them a challenge, start with silhouettes before trying to paint them in the middle distance.

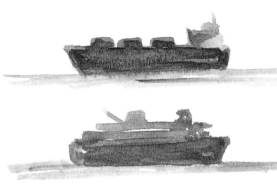

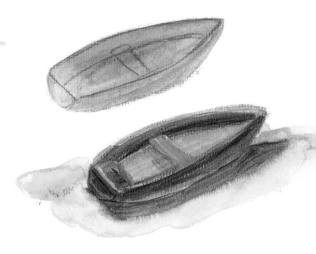

Simple silhouettes can be very effective. Use a dark grey tone and the No.4 round brush. Note how details like the cargo and funnel help these boats to look realistic.

This rowing boat looks flat and has no form until the shadows are added.

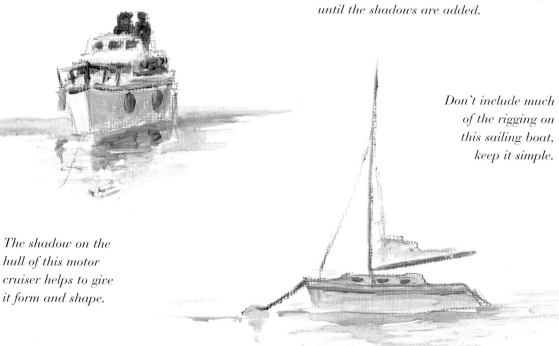

Don't include much of the rigging on this sailing boat, keep it simple.

The shadow on the hull of this motor cruiser helps to give it form and shape.

Fishing boat

Harbours are great subjects to paint, but fishing boats can seem rather complicated at first. Try this one and then practise painting others of your own, but don't attempt to put in all the details and equipment.

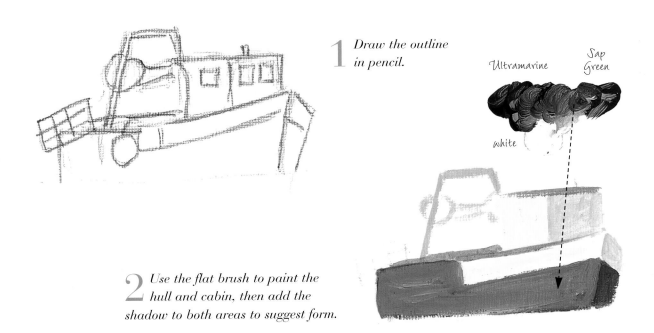

1 *Draw the outline in pencil.*

Ultramarine

Sap Green

white

2 *Use the flat brush to paint the hull and cabin, then add the shadow to both areas to suggest form.*

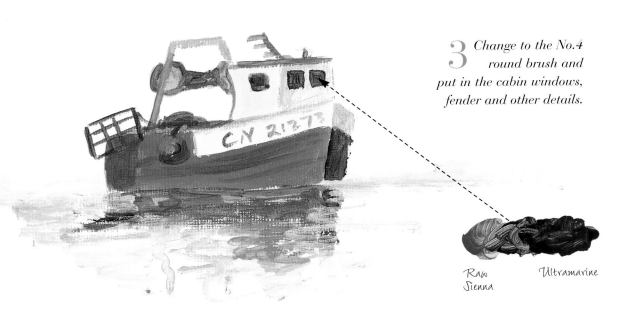

CN 21273

3 *Change to the No.4 round brush and put in the cabin windows, fender and other details.*

Raw Sienna

Ultramarine

Deck chairs

Deck chairs are a familiar sight on most beaches. I love their bright stripes and the way they blow around in the wind when no-one is sitting in them. They are much easier to paint than to put up!

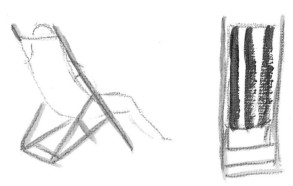

1 *Start with Raw Sienna for the wooden frames, painting these lines with the edge of the flat brush. Put in the stripes on the canvas with pure Ultramarine. Use dry brush strokes and the full width of the flat brush.*

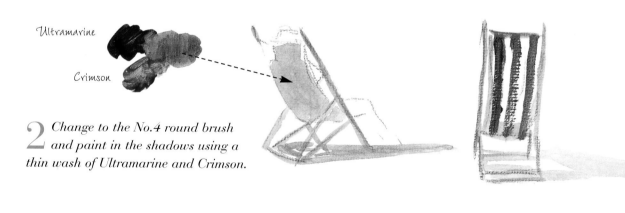

Ultramarine

Crimson

2 *Change to the No.4 round brush and paint in the shadows using a thin wash of Ultramarine and Crimson.*

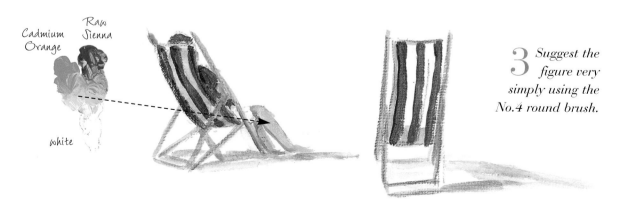

Cadmium Orange

Raw Sienna

white

3 *Suggest the figure very simply using the No.4 round brush.*

Building a sand castle

Memories of childhood come flooding back every time I see children building sand castles. This is one time when children will stay relatively still, giving you a little more time to paint them.

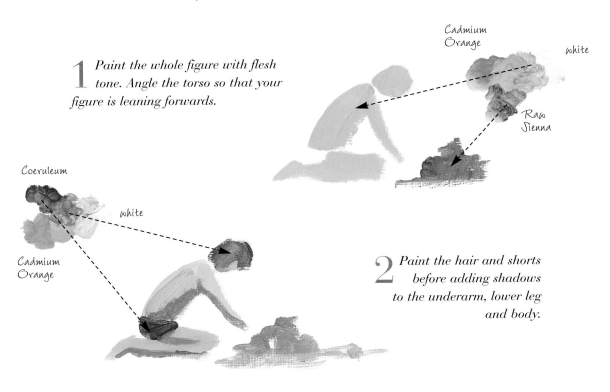

1 *Paint the whole figure with flesh tone. Angle the torso so that your figure is leaning forwards.*

Cadmium Orange

white

Raw Sienna

Coeruleum

white

Cadmium Orange

2 *Paint the hair and shorts before adding shadows to the underarm, lower leg and body.*

3 *Highlights on the boy's back, shoulders and feet add form and shape, whilst the background is useful to cover any unwanted rough edges on the figure and sand castle.*

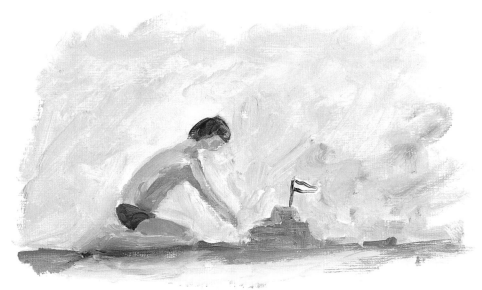

AT A GLANCE...

 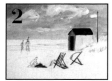 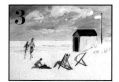 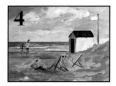 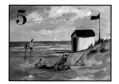

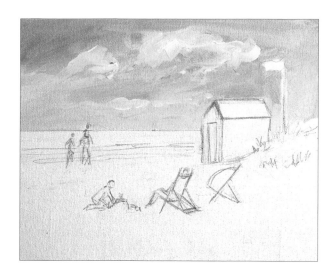

1 *After drawing in the main elements of this beach scene with a 2B pencil, start with the sky. This is the biggest area to paint, so will set the tone for the rest of the painting. Use the watercolour brush loaded with Ultramarine and white for the top of the sky, changing to Coeruleum and Raw Sienna towards the horizon. The clouds are white at the top and purple underneath (Crimson, Ultramarine and white).*

2 *Paint the beach hut roof and flagpole with Cadmium Orange and Ultramarine using the flat brush. The sharp edge of this brush makes it easy to paint thin lines. Shadows on the walls of the beach hut are Crimson, Ultramarine and white. Use Raw Sienna for the wooden deck chairs and sand castle. The deck chair covers are white with stripes of Coeruleum.*

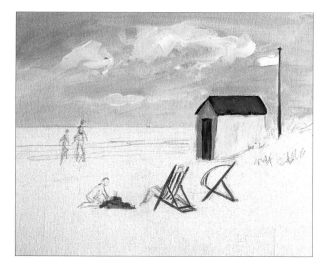

The palette

 Ultramarine

 Titanium White

 Crimson

 Raw Sienna

 Cadmium Orange

 Coeruleum

 Lemon Yellow

 Sap Green

3 *Now for the figures. Mix Cadmium Orange, Raw Sienna and white for the basic flesh tone and use the No.4 round brush to paint each figure. Add T-shirts, swimwear and shorts onto each figure after the flesh colour has dried, and don't forget to give each person some hair.*

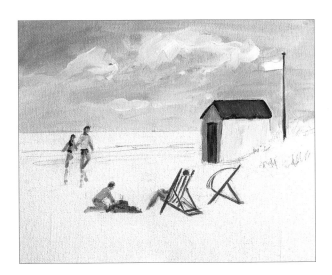

4 *Use the watercolour brush to paint in the sea and beach. Mix Coeruleum, Ultramarine and white for the distant sea, adding Raw Sienna for the shallower water. Use more Raw Sienna with white for the beach, plus a little Lemon Yellow in the foreground.*

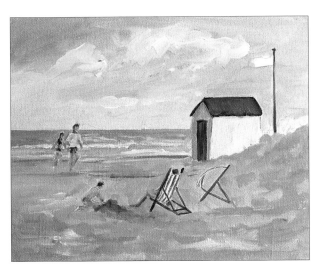

5 **_Finished picture:_** _Canvas board,
25 x 30 cm (10 x 12 in). Use the sharp
edge of the flat brush to paint in the grasses on
the sand dune (Sap Green and Ultramarine).
Then mix a shadow colour (Crimson and
Ultramarine). Using the watercolour brush and
plenty of water, paint shadows under the deck
chairs and figures as well as to the left of the
beach hut. Finish off your beach scene with a
red flag on the pole and the sand castle, and
paint a white yacht on the horizon._

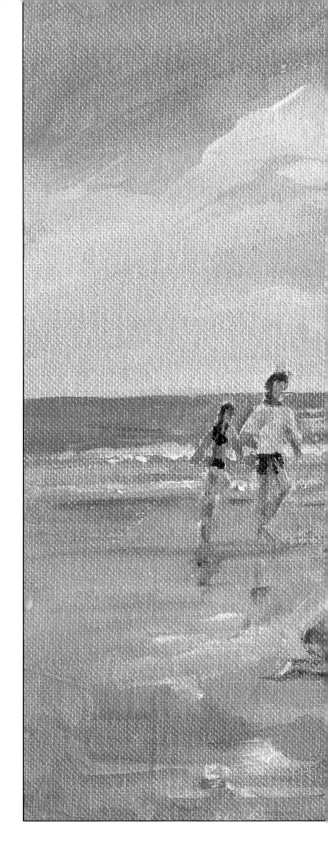

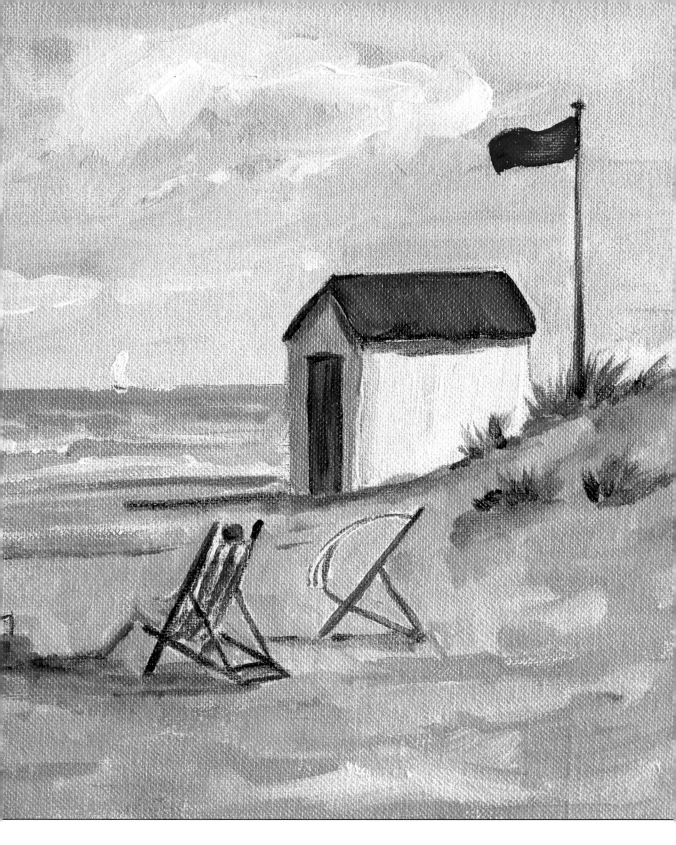

PAINTING ON HOLIDAY

When you travel on holiday, particularly abroad, always take a few paints and a sketchbook with you. Acrylics are easy to transport, being watersoluble and therefore safe to take into an aircraft. A small water sprayer is a useful extra to keep the surface of your stay-wet palette damp.

Flower stall

In this study of a flower stall in southern France, see how the sunflowers on the right-hand side help to guide the eye into the picture. Try to include some recognizable flowers rather than just coloured blobs. The end result is much more pleasing to the eye.

I sketched in the market stall and its umbrella first of all, as this made it easier to place the figures in a good composition. The background tree was added later.

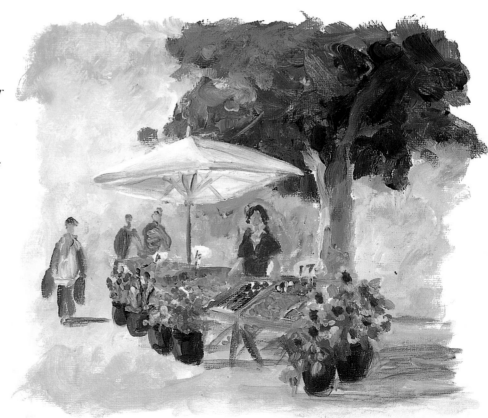

Sketching abroad

Finding interesting subjects to sketch on holiday is usually very easy: there is often too much choice! Rather than try to produce finished paintings, concentrate on making as many quick studies as you can. Here are a few suggestions from my own travels.

Vases:
I used several thin washes of Raw Sienna to paint these vases, lying in front of a house in Greece.

Gondola:
The red ribbon on the straw hat in this gondola makes an excellent focal point as well as adding a spot of colour.

Watermelons:
These watermelons in the corner of a French market caught my eye with their strong colours. Subjects like this make useful studies for inclusion in large paintings back at my studio.

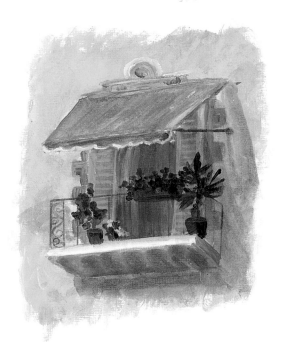

Balcony:
Balconies are a familiar sight in warm Mediterranean countries. The pink wash of the wall behind made an interesting contrast to the blue canopy and green shutters.

AT A GLANCE...

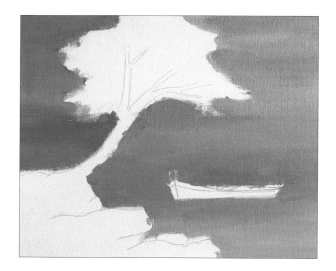

1 Draw in the boat and overhanging olive tree with a 2B pencil. Using the watercolour brush, paint a graded wash for the sky and water. Start with Ultramarine and white, gradually changing the blue to Coeruleum and then adding a little Lemon Yellow to the mix as you paint towards the bottom of the picture. These strong colours, particularly the turquoise shades, are very evocative of the Mediterranean.

2 Next, paint the trunk of the olive tree in a warm brown using Coeruleum, Cadmium Orange and white. Use the flat brush for this with brush strokes going around the tree trunk as well as along its length. Use a dark grey (Ultramarine and Cadmium Orange) for the shadows between the rocks, before painting the boat's hull with white, Coeruleum and Crimson.

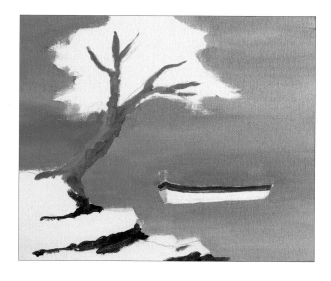

The palette

Ultramarine

Coeruleum

Titanium
White

Lemon
Yellow

Cadmium
Orange

Crimson

Sap
Green

Raw
Sienna

3 *Now for the leaves on the olive tree. Start with your darkest green (Sap Green and Ultramarine) and use the flat brush to block in areas of dark foliage. Leave a few gaps for adding the highlights in the next stage. Paint the rocks with Raw Sienna and a little white, greyed down with Coeruleum, leaving the top of the rocks for the highlights.*

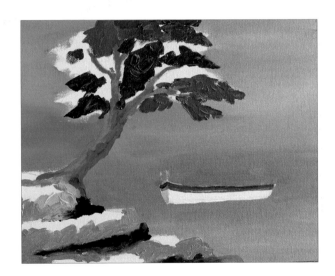

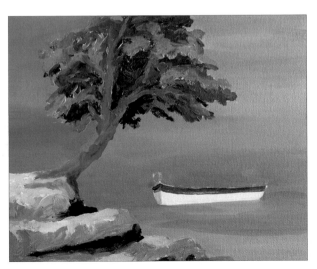

4 *Highlights on the olive tree are Sap Green and Raw Sienna with a little white added. Use the flat brush and vary the direction of your brush strokes for a lively, textured finish. Using the same technique (with white and Raw Sienna), paint the highlights on the rocks.*

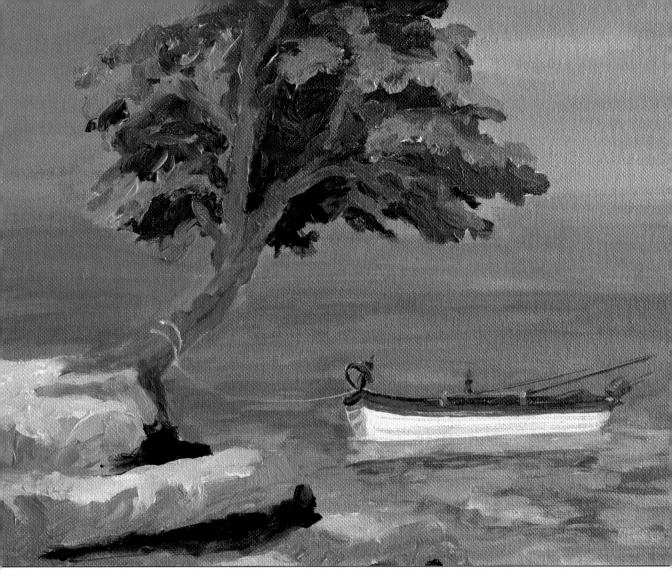

5 *Finished picture: Canvas board, 25 x 30 cm (10 x 12 in). Use the watercolour brush to add ripples to the surface of the water. Mix the same colours as the underlying wash (Ultramarine, Coeruleum, Lemon Yellow and white) but don't add much water. Take your time with this stage, and use fairly light pressure on the brush for a soft effect. Put in the details on the boat with the No.4 round brush using Burnt Sienna for the oars and lamp on the bows. Finally, paint the mooring rope with Raw Sienna and white.*